In warm appreciation
to the many professional and amateur photographers
who generously shared their knowledge with us,
thereby making this book possible.

Library of Congress Cataloging in Publication Data

Mike Q.
 Manual of slide duplicating.

 Includes index.
 1. Slides (Photography)—Copying. I. Pat, Q.,
joint author. II. Title.
TR 505.M54 770'.283 78-1878

ISBN 0-8174-2426-1

Manufactured in the United States of America.

Third Printing, 1980

The Manu
of Slide
Duplicati

Mike and Pat Q

AMPHOTO
American Photographic Book Pu
New York, New York 1003

The Manual of Slide Duplicating

Mike and Pat Q

AMPHOTO
American Photographic Book Publishing
New York, New York 10036

In warm appreciation
to the many professional and amateur photographers
who generously shared their knowledge with us,
thereby making this book possible.

Library of Congress Cataloging in Publication Data

Mike Q.
 Manual of slide duplicating.

 Includes index.
 1. Slides (Photography)—Copying. I. Pat, Q.,
joint author. II. Title.
TR 505.M54 770'.283 78-1878

ISBN 0-8174-2426-1

Manufactured in the United States of America.

Third Printing, 1980

Contents

Acknowledgment

A special thanks to all the many
manufacturers who have contributed technical
information and photographs of their products for
use in this book, particularly the technical staff and
management of the Eastman Kodak Company.

To our photographic friends, Dr. Felix
Axelrad, C. Chu, William Garlick, and Father
Renato Saudelli, we are indebted for the use of their
photographs, and to our son, Jay, for his illustrative
drawings.

We also wish to thank Spiratone Inc. for
permitting us to use their word, rephotography, in
this book.

Introduction

WHY MAKE SLIDE DUPLICATES

In the last 25 years photography has moved in the direction of smaller film and equipment. Except for the snapshot equipment available 35 mm photography is by far the most popular format. An unbelievable array of lenses, cameras, and special devices is available for almost every form and type of photography. Because of its popularity and because most 35 mm photography is done on transparency material—to be used primarily for projection—the need for the duplication of slide materials has arisen. If anything, in the next 25 years this need will be even greater.

Most people who make 35 mm color slides are usually asked for duplicates of them. They may be a series or group of slides taken on a special occasion or in a particular place. If your need for duplicates is infrequent, sending your slides to a good commercial color lab is probably the most practical procedure. However, if your need for duplicate slides is constant, knowing how to do it yourself has its advantages.

Just as the professional photographer who works with black-and-white, or color negatives and prints can improve the quality of his or her work—through the controls available in the darkroom—so can the slide maker. To the slide maker, rephotography offers the same controls and benefits. One could say that rephotography is the darkroom work of the color slide maker.

For those interested in selling photographs to publications, it is, of course, a risky practice to send originals to prospective buyers or agencies, particularly if you have had no prior dealings with these organizations. It is much wiser to send a clearly marked duplicate of the slide. In the first place this authenticates the ownership, should there ever be a question, and secondly, it protects you from financial loss if there is a problem with mails or shipping. Finally, if your duplicates are clearly marked as such, your artwork will be less liable to unauthorized use or publication.

If you use your slides frequently, there is another advantage in duplicating them. Projection systems generate tremendous amounts of heat and even if cooling systems in a projector are efficient, projected slides are subject to heat fading. Valuable slides can be safely stored while duplicates are projected and faded slides can be replaced with minimum effort or expense. By the same token, important old slides can benefit from duplication or rephotography.

If you intend to produce slide shows or combine slides with sound for multimedia programs, it is good practice to use duplicate slides for the many repeated viewings and editings required in the production. This protects your original films from fading or damage. When masks are added or gels are used for color effects, the extra thickness may prevent proper focusing. By reducing the multilayer originals to a single emulsion through rephotography, you can eliminate this problem.

Today more and more slides are being used for instruction and training. The ability to reproduce a successful program as many times as you require can certainly be very valuable. These copies can be shared with others who teach the same subject, sold, or preserved, as necessary.

Research projects require slides for presentation or evaluation. Valuable originals may be protected by making slide copies. In the duplicating process you can also improve a slide show by adding black, white, or colored titles to the slides. In a research project this might include arrows, circles, or special indicators to designate an area of interest as well as size, magnification, proportion, or direction. This sometimes requires combining two slides. To do this effectively, it may be necessary to enlarge or reduce the image size of one or both originals for best results. This, of course, can be accomplished only through rephotography.

In addition to duplicating slides in quantity and adding graphics, there are many changes that can be made in the rephotography process to improve the original slide. Rephotography permits making moderate changes in density and color balance as well as improvements in cropping. Masks and story-telling shapes can add considerable impact to a slide. You can enhance originals with special techniques or change their composition by the magnification of certain areas. Some slides can be greatly improved by intentionally rephotographing them wrong side up (flopped).

Chapters 4 and 5 explain the techniques that often turn an "ugly duckling" into an "elegant swan." A glance through the table of contents will give you an idea of the many controls and treatments available to improve slides both by rephotography and chemical treatment.

Whether you are a novice facing your first baptism of film or an old pro who has never been quite satisfied with rephotography results, this book is dedicated to helping you develop and improve your skills in this ever-expanding field of photography.

8

What Equipment to Use

Before discussing the various types of equipment used in close-up or duplicating photography, it might be best to define a few basic terms relating to this type of work. The term "close-up" photography usually refers to recording images 1:10 (1/10) their original size to a magnification of 1:1 (same size). "Ultra close-up" photography begins at the 1:1 ratio and includes up to three times the size of the original subject. Magnifications larger than three times the size of the original subject are usually called photomacrographs and require special optical equipment. Since slide rephotography is essentially reproducing an image that is the same size (1:1) as the original, slide duplicating falls into the category of ultra close-up photography.

THE SINGLE-LENS REFLEX VS. THE RANGEFINDER

Both the single-lens reflex and the rangefinder are equipped with lenses capable of focusing from infinity to 18 inches. Their function is to take large objects and scenes and make them small. Since slide duplication requires focusing at approximately four inches to achieve the 1:1 ratio, these lenses are not adequate. While supplementary close-up lenses alter the focal length of the lens and permit closer focusing, several of these would be necessary. This radically limits range of movement and rarely produces sharp, high-quality images.

Of the two types of 35 mm cameras, the rangefinder is the least desirable for this kind of work. It does not offer many of the required features, and although it can be fitted with supplementary lenses to focus in the duplication range of rephotography, at best, you must guess at what you are going to get in your final slide. This can cause serious problems and slow you down when there are a considerable number of transparencies to duplicate. Manipulating close-up lenses with their var-

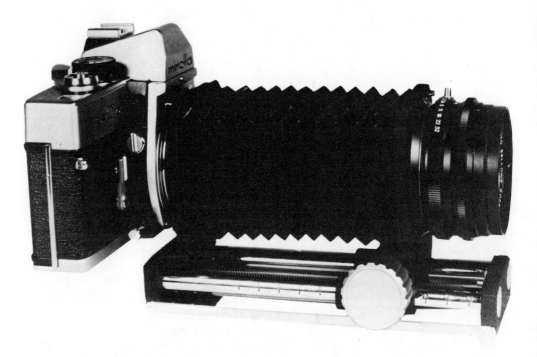

Minolta makes a bellows system with its own macro lens that can be mounted directly onto the Minolta camera.

ious magnification powers can also be time-consuming and awkward when a series of slides of varying magnifications must be duplicated.

The most practical type of camera is the single-lens reflex because it offers the interchangeability of lenses, a viewing field that is almost the same as the film frame, and in many cases, a built-in through-the-lens exposure meter system that compensates for the extension of the lens and the resulting loss of light. The built-in meter is very handy in making initial tests and determining the variables between slide densities.

The single-lens reflex is ideal, but it is by no means perfect. The area seen in the viewfinder will not be the total image that you photograph. Most viewfinders show only 90–95 percent of the image you get on film. When making slides you have to mentally compensate for the extra bit of frame that will be showing. Once you know your equipment, it is relatively simple to frame perfectly. Some companies, such as Nikon, have models that show in the viewfinder the exact image which will be

recorded on film. With equipment like this you can see precisely what will be projected.

Making good copy slides with a 35 mm SLR camera is a simple procedure as long as you remember that the camera must be centered and absolutely parallel to the original copy. The original copy must be held perfectly flat, without waves or wrinkles, which cast shadows and degrade the quality of the copy.

This Nikon precision bellows unit is designed for close-up photography with a Nikon or Nikkormat camera.

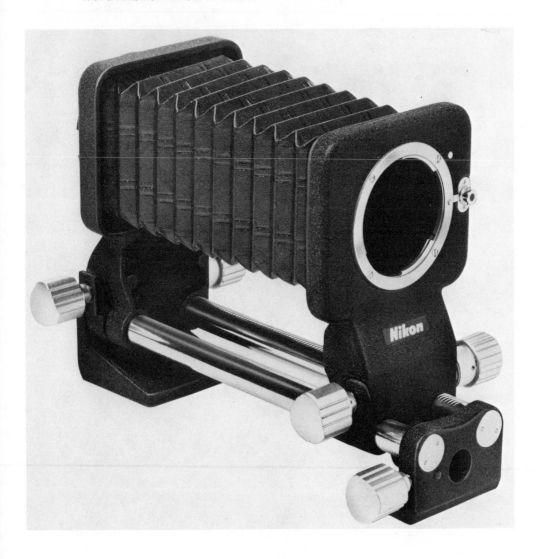

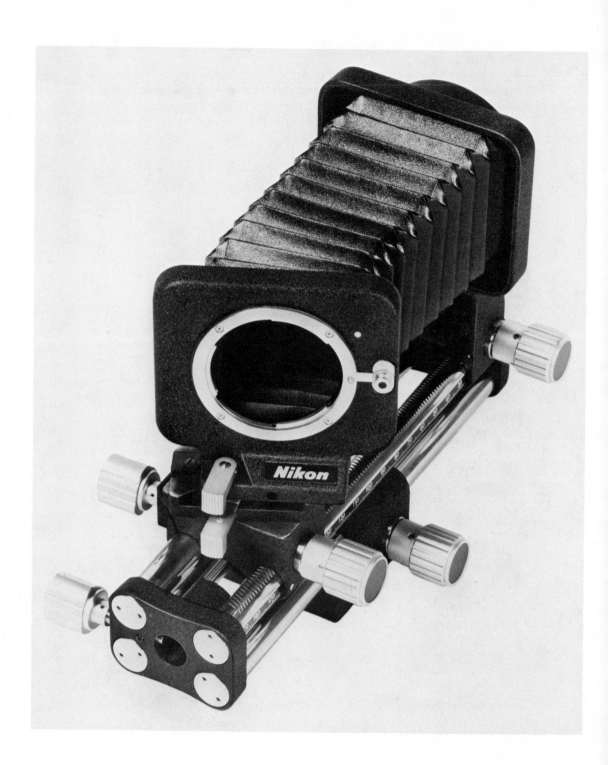

The rail-and-distortion correction device built into this Nikon bellows unit (left) corrects parallax in the rephotography process.

Canon designed a macro lens and a life-size adapter that extends the normal 50 mm lens for 1:1 photography.

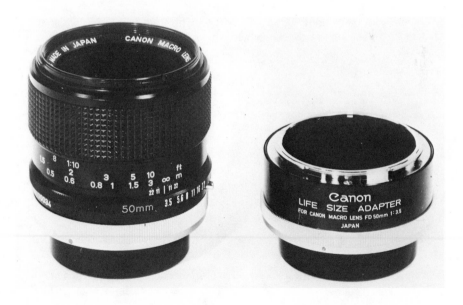

Every SLR with interchangeable-lens capacity can be fitted with extension tubes.
They may be used singly or in combination to achieve the desired magnification.

(Opposite) A combination of extension tubes placed between a normal lens and a
camera body permits close-up photography.

DEVICES

As in any other form of photography, there is a wide variety of equipment available for slide duplication. Prices of equipment can range from $20 to many thousands of dollars. Very often, the inexpensive equipment will do a remarkably fine job. But for someone involved in professional slide rephotography, a more costly system offers advantages and saves time and effort.

Extension Tubes and Bellows

The simplest device for close-up photography is a series of extension tubes. These fit between the camera and lens and permit the lens to extend its close-up capabilities by moving the lens further from the film plane thus increasing magnification. Because they come in a series of widths in sets, you can utilize one or a combination of tubes to vary the

degree of magnification and control how close you get to your subject. They lock to the camera body with fitted adapters. The other end is designed to accommodate your lens. Automatic tubes permit the function of the f-stop or diaphragm to be transmitted to the lens so the camera may be used in its normal manner. Using manual tubes—which are less costly—requires manual adjustment of the aperture. Although these tubes do an excellent job of permitting ultra close-up photography, they are somewhat more time-consuming than some other devices.

Another means of extension utilizes the bellows system. This fits between the lens, or macro lens, and the camera body and permits the lens to move further from the film plane. Extension tubes or bellows can be purchased two different ways. Most camera manufacturers produce a line of bellows or extension tubes specifically designed for their cameras. Other manufacturers rely on adapter rings to fit them to each individual camera.

Minolta designed a low-cost Celtic macro lens for the photographer with limited funds.

16

The Canon 100 mm Macro lens with an extension tube permits much closer close-up photography.

Macro Lenses

In recent years, the development of macro lenses has increased rephotography capabilities. Some macro lenses shift focal length by moving an internal lens component, making these lenses more suitable for ultra close-up photography. A normal camera lens, when inverted, can yield results much like a macro lens. Many manufacturers make inverters so the lens can be reverse-mounted. These work reasonably well, but will not produce the same quality that macro lenses are capable of since the latter are specifically designed for this purpose. Remember, the end product can only be as good as the optics you use.

Slide Copiers

A slide copier is a device that locks onto the camera and is adjustable in length by one tube within another or by a bellows extension. The tubes or bellows slide back and forth to control the degree of magnification. One end locks to the camera or lens, depending on the type copier,

Almost every major camera manufacturer produces at least one macro lens for its cameras. Here is one of Nikon's.

and the other end holds your original slide. Behind the slide is a milk-white glass or plastic diffuser that diffuses the light illuminating the slides, thereby eliminating hot spots. These come in a variety of units, each offering varying features and capacities in their degrees of magnification. Some of these units utilize the camera lens while others contain a special copy lens which is ideal for rephotography. These units allow you to focus on the full slide or on only a segment of a slide.

Lighting Sources

All the aforementioned units require an individual exposing light source. The Testrite Instrument Co. manufactures several illuminators that hold slides. You can suspend your camera above the illuminator by using a tripod or copystand. This tends to simplify rephotography because

the entire unit is suspended rigidly. When you are working at extreme magnifications, any movement or vibration of the camera during extended exposures can blur the image. A solid system that keeps the camera in a firm, fixed position is advantageous.

The Air Release

You might also consider an air release—a device with a bulb at one end, a tube which can be cut to any desired length, and a release that fits

Nikon's lens inverter is designed to make the conventional camera lens useful for duplicating or close-up photography. The unit locks directly onto the camera and functions as an accessory. It permits the photographer to set the f-stop accurately even though the aperture scale is concealed from view. It also indicates the degree of magnification.

into the camera's cable-release socket. The advantage of an air release, over a cable release, is that you can make long or slow exposures without transmitting vibrations to the camera, thereby maintaining sharpness.

Other Accessories

Many camera systems offer right-angle finders for their camera equipment. Some offer critical focusing magnifiers to aid the ultra close-up photographer. These can be very useful in the production of duplicate slides as well as close-up photography. Nikon and a number of other companies have special carriers that facilitate the production of filmstrips, as well as individually mounted 35 mm slide films.

AUTOMATED EQUIPMENT

Those who intend to do slide duplicating professionally will probably prefer more automated equipment such as the Bowens Illumitran Three and the Sickles Optical Printer. Sickles produces a line of quality professional equipment that incorporates dichroic exposing filters and magazines which permit mass production of duplicates.

A simple bellows attachment, this one by Spiratone, affords the user variable magnification and lens interchangeability. The bellows extension on this attachment is decreased by turning the knob (inset).

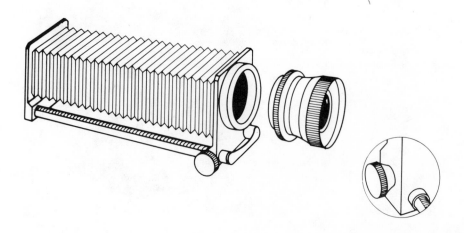

This simple duplicating attachment mounts directly on the front of a normal lens with a Series 7 filter holder. It is usually used in conjunction with extension tubes or a bellows. More elaborate units contain built-in extension tubes. Other units with built-in optics are available that are mounted directly on the camera body with a fitted adapter.

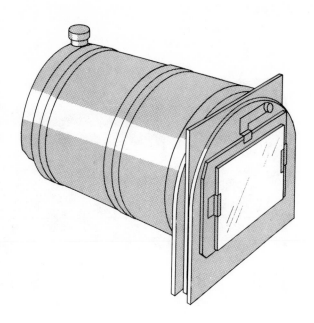

This illuminated slide copier, manufactured by Testrite, is designed exclusively for the use of an electronic flash. You supply your own unit that flashes through an open port and evenly illuminates the slide.

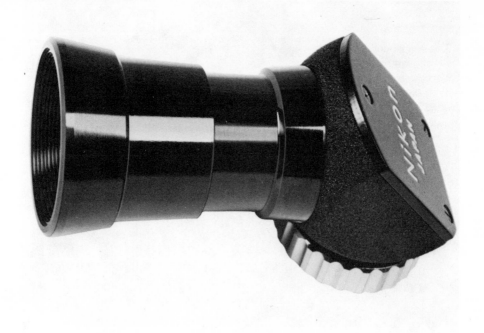

The Nikon right-angle finder mounts on the viewfinder of the camera.

(Opposite) By mounting a camera on a tripod (left), it can be suspended over the Testrite-Kingdon Illuminated Slide Copier. The top of the copier holds the slide in position, and the lower section holds filters for color correction. (Right) By attaching a small electronic flash to the lower section and suspending the camera on a tripod over the copier, daylight-balanced film can be duplicated without excessive filtration.

The Bowens Illumitran Three is a versatile unit offering continual variable light output coupled to a direct-reading exposure meter that gives exposure control. Constant-color temperature output flash eliminates reciprocity failure. The unit features a high-output switch for duping films. It rephotographs from half-frame 35 mm to 4″ × 5″ film. The unit permits cropping and correcting over- and underexposure. Both standards of the bellows assembly move individually. The entire assembly can be removed or replaced in seconds. The Illumitran Three is equipped with a split-image mirror and lighting unit which permits duplicating your original and flashing the film to reduce contrast, both in a single exposure.

The Sickles 3100 Optical Printer is ideal for the mass producer of slide duplicates. Its function falls between the large expensive console

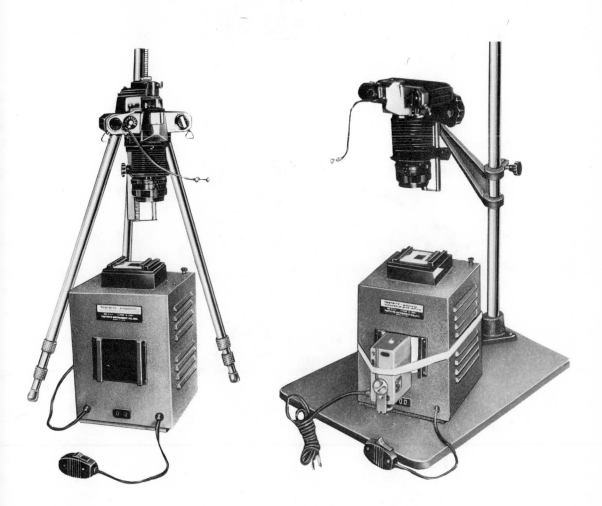

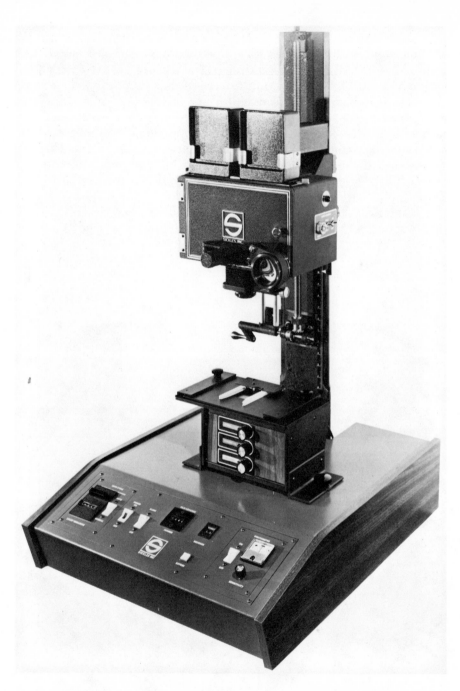

The Sickles 3100 Optical Printer is ideal for the mass producer of duplicate slides. It will accommodate several film sizes and can be automated to produce at high speed.

24

printers and the small limited-production slide duplicators. By using quartz 3200 K illumination, it is designed to use duping stock at a substantial cost savings over regular camera film. It may be equipped with special side illuminators that will accommodate flat copies of opaque materials up to 11″ × 14″. There are also options to automate the printer for automatic slide duplication. One hundred-foot magazines can be accommodated to minimize film loading and unloading. The unit has a 50 mm $f/4$ EL Nikkor lens and Geneva Star precision film transport. This is but one of the many units produced by Sickles Inc.

Spiratone's right-angle finder mounts on any 35 mm camera. Spiratone's finders are available for most popular SLRs.

Nikon's magnifying finders aid critical focusing. The unit is beneficial for those who wear glasses and require diopter correction for working extremely close.

Spiratone's Magnifying Finder is hinged so it can be swung out of the way when it is not being used.

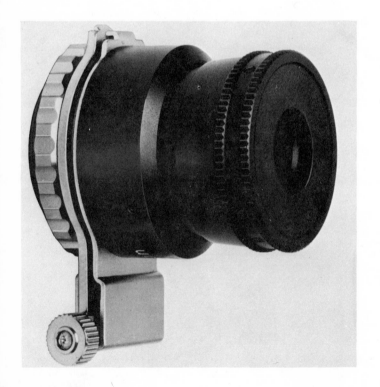

Nikon makes a magnifying finder with a hinged mount that permits it to be raised when it is not in use.

PROJECTION

Another direct method for reproducing slides of good quality and acceptable resolution is through the use of a standard projector and special rear projection screen material. One such rear projection screen is manufactured by Visual Products, a division of the 3M Co. These screens are specially designed for making copies and titles and provide good contrast and color fidelity in normal or studio lighting. They are useful for slide copying, special effects, cropping, dodging, changing backgrounds, converting slides to filmstrips, and straightening lines (correcting distortion). The material is $18'' \times 18''$ and $\frac{1}{16}''$ thick. The screen provides uniform division of light over a wide angle. It is built of long-lasting, flexible acrylic, which permits curving the screen for special effects. Two other sources of rear projection material—for those who might require smaller or larger screens—are the Edmund Scientific Co. which handles a line of smaller materials, and Rosco Laboratories Inc. which handles a line of larger materials.

Nikon's slide-copying adapter (left) attaches to the Nikon bellows focusing attachment and is used for precision cropping of magnified areas. By attaching a filmstrip holder (right) to your slide-copying adapter, you can directly photograph a filmstrip.

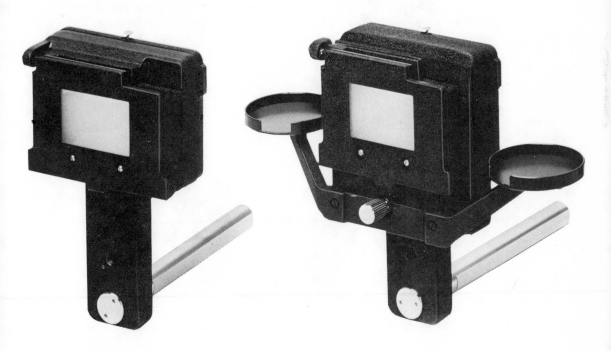

TRIPODS AND COPYSTANDS

If you use a simple duplicator or a set of extension rings that lock to the front of your camera and conventional daylight color film, you can point your camera at a light source such as the sky, adjust your meter to obtain an accurate reading, and make your exposure by hand-holding the camera. For most duplicating, it is best to affix the camera to a tripod or copystand to insure absolute rigidity. Since your objective is to avoid vibrations, it is essential to use a cable or air release with either of these methods so vibrations are not transmitted in the process of releasing the shutter. The copystand is probably better designed to make sharp duplicates, but tripods—if they are well constructed—will work. (The accompanying illustrations represent some of the units available.) With a bellows unit, where the lens loses a great deal of speed because of the bellows-extension factor, longer exposures are required. Mounting the camera simplifies the job.

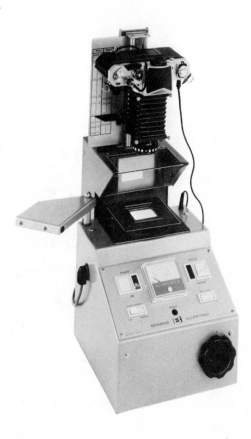

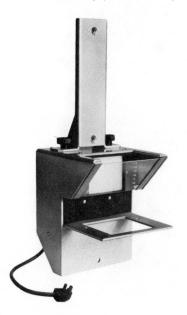

The Bowens Illumitran Three is a versatile automated slide duplicator featuring, among other things, a split-image mirror and lighting unit and a removable bellows assembly (shown below).

28

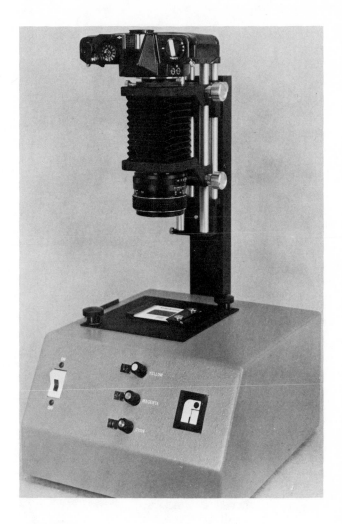

The moderately priced Sickles D1 Dichroic Slide Duplicator accommodates Kodak E-6 Ektachrome duplicating film under tungsten illumination. This system permits the material to be used with a minimum amount of filtration. The dichroic illuminator is built similar to the color head in any modern color enlarger and permits stepless filtration that is precisely repeatable with fadeproof filters. The unit will also accept any 35 mm SLR as well as original films as large as 2¼" square. *(Photo by Focus International.)*

FILMS

Camera films come in both daylight and tungsten types. Basically, this means that the color balance of the daylight film will give more realistic and true rendition when used in daylight situations. When these films are used in tungsten light they develop a very strong and overpowering yellow-red cast that gives an unnatural look to the picture. Tungsten films are balanced so they will make more natural transparencies when using any source of tungsten illumination.

Both films have to be modified with filters in front of the lens when they are used to make pictures in fluorescent lights. Magenta or red filters, or a combination of both, make up for the lack of red in fluorescent lights and correct the color balance. Professional duplicating films are

Nikon's exceptionally well-constructed camera stand is built to accommodate the Nikon and Nikkormat cameras. It can be used to suspend the camera above an illuminated viewer.

The drawing at right shows the correct way (above) and the wrong way (below) to project pictures for an audience. The same rear projection screen used for showing slides is excellent for rephotographing slides as well. *(Courtesy of Edmund Scientific Company.)*

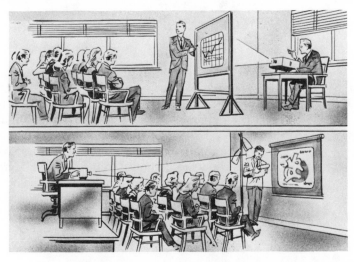

balanced to tungsten illumination. It is important to use the correct source of illumination for the film that you are planning to use. Mismatching the film and light source will require a considerable amount of filtration to correct for the error in color temperature.

THE ELECTRONIC FLASH SCALE

Spiratone Inc. makes an interesting device that uses an electronic flash scale with precalculated exposure settings on which the flash is placed. By setting the flash on the appropriate ASA for your film, you can take correctly exposed duplicate slides. The scale is designed to accommodate all conventional film speeds. The flash is powered by two standard pen light electronic batteries. If you have an electronic flash and wish to do a series of tests, you can make a similar device at home. The secret of good color rephotography is repeatability. Once you develop a method of working, you will find that the high quality of today's emulsions permits you to produce consistently good results.

FILTERS

Whenever film is exposed with an incorrect light source, a more pleasing balance of color is achieved by rephotographing the slide with

Spiratone's exposure-calibrated, duplicating electronic-flash light system consists of an electronic flash, an extension cord to permit its use with the PC connector on your camera, and an ASA scale that has been calculated to take all the bellows extension factors into consideration.

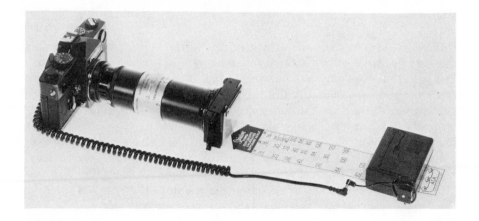

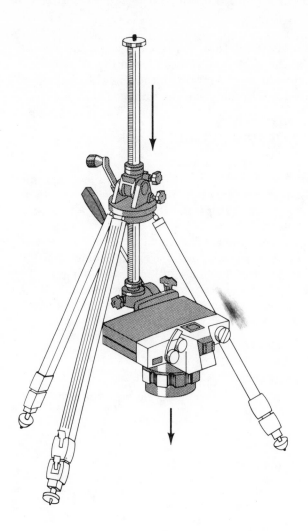

Spiratone's tripod is built to accommodate the mounting of a camera between the legs at the bottom of the centerpost so the camera will be properly positioned above an illuminated viewer.

filters. This can be done with three kinds of filters. The same glass filter that can be attached to your lens by an adapter or screw-in mount for use in normal photography can be used in rephotography. Because they are made of glass, are optically flat, and are polished to be parallel on both sides, these filters are the most expensive of the three kinds. Another optically flat but less expensive filter is the gelatin, or gel, designed for use in enlarging color negatives. The third filter, also a gel, is not optically flat since it is not designed for use in front of the camera lens, rather, it is placed out of the optical path, beneath the slide and the diffusion glass. These are the cheapest filters since they are not made to exacting specifications. (See Chapter 5 for more information.)

The Testrite copystand
—a simple, inexpensive
stand—allows you to
mount the camera so it
can be suspended
above an illuminated
viewer.

SCREENS

Some slides can be improved or otherwise enhanced by rephotographing them in conjunction with special screens. By superimposing a texture, such as grain or ripples, over a slide, different effects can be achieved. These texture screens can be bought, or you can design your own. Each time you go out with your camera, watch for interesting textures and patterns. They are frequently found in weathered wood, tree bark, sand, and even ripples in water. By making some extra photographs of these subjects you can develop your own file of texture screens. (See Chapter 5 for more information.)

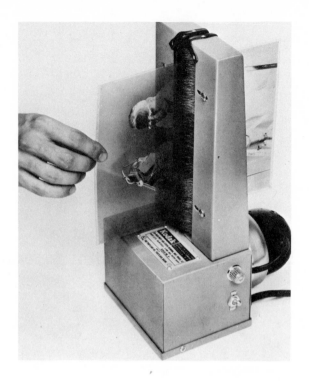

Kodak's 10-inch Dust and Static Removal Unit, Model A2-K removes dust and electrostatic charges from negatives, filters, and other non-sensitized photographic materials up to 8″ × 10″.

The 3M Co. makes a C.A.T. rear projection screen that is used for duping copies and titles.

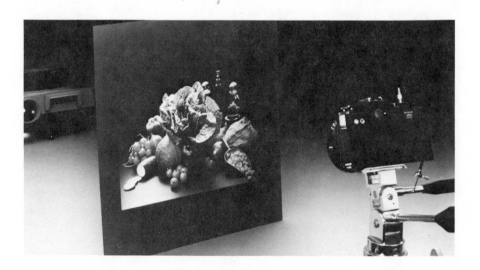

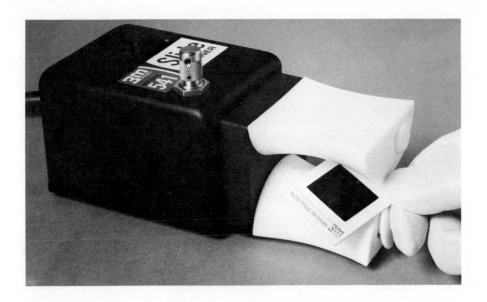

By passing a slide between specially designed cleaning heads, the 3M-brand "541"
Slide Cleaner removes dust and lint, and eliminates static charge. At the same time,
dust-attracting static is neutralized by an ionizing air nozzle.

These 3M Nuclear Static
Eliminators, available in 1-inch
and 3-inch widths, are
practical for eliminating static
electricity.

PRODUCTS FOR CLEANING YOUR FILM

The film you are duplicating should always be as clean as possible. Specks on the film reproduce as black marks on your duplicate. Static charge, captured on film, shows up as static streaks. Static charge is generated when two materials come into contact and are separated. As the materials are separated, one surface assumes a positive charge, the other a negative charge. When the charge material is brought within proximity of a grounded or metal object, the charge material may discharge to that object. If the difference in charges is great enough, the discharge will take the form of a visible spark. This spark is often captured on film and seen as static streaks. There are a number of gadgets that will help in this area. Nuclear Products makes static master brushes in 1-inch and 3-inch widths. The 3M Nuclear Static Eliminators utilize safely encapsulated polonium 210. Polonium 210 radiates low-energy alpha particles. Since alpha particles will not penetrate a sheet of ordinary paper, the brush can face the emulsion side of undeveloped film without fogging it. Static eliminators can be used in almost every application of darkroom work.

The 3M Co. also manufactures a slide cleaner ideal for mounted or unmounted slides and cut negatives. Several companies produce compressed-air or small bulb-type blowers or brushes which will work, but not quite as well, because they do not eliminate the static electricity. Large labs use a number of electro-static eliminators. Kodak makes one that is very effective.

Before you set up for slide duplicating, it pays to speak to one or two people who have experience in this area. Find out what results they've had with various types of available equipment. Based on your needs, invest in the best equipment you can afford. You will find the investment will return dividends in many satisfying ways.

Duplicating Film

Although any color reversal film may be used for duplication or rephotography of slides, it is best to limit yourself to films that you can self-process. It is also advisable to use films that are readily accessible and offer the greatest consistency to simplify your work. If you make an occasional slide duplicate, it will be easiest for you to use a reversal film with which you are familiar. At the end of this chapter, in the section on flashing, we cover the procedure for preparing these films so the contrast range will be adjusted for best results. For those of you who are going to do more duplicating, Kodak Duplicating Film No. 6121 (Process E-6) is what the best professional labs use. This film has a remarkable latitude for error in exposure and a considerable latitude in color balance. Because it is sold only in bulk rolls, it is not for the casual user. Anyone who has access to a darkroom or loading bag, and a sink with hot and cold running water can process this material with relative simplicity.

HISTORICAL BACKGROUND

The first Kodak Ektachrome films were introduced in 1946 as daylight and type B sheet films for professional photographers. The daylight type had an ASA of 12, and type B, ASA 10. Process E-1 enabled photographers to process their own transparencies in about 90 minutes at 20 C (68 F). A short time later, 120-size professional film—in both daylight type and type B—became available. In 1949, the temperature of Process E-1 was increased to 24 C (75 F), and the processing time was reduced to 67 minutes.

In 1955, consumer (amateur) films were introduced for miniature and roll-film cameras. The daylight type had an ASA of 32. Type F was available for exposure with clear flash lamps. These films were processed in Process E-2 chemicals at temperatures and times similar to those for Process E-1.

In 1959, improved Ektachrome professional sheet films and roll films having higher speeds (ASA 50 for daylight and ASA 32 for type B) and improved color-rendition and resolution characteristics were introduced, along with new Process E-3 chemicals. Later in 1959, high-speed Ektachrome films followed, ASA 160 for the daylight type and ASA 125 for type B.

In 1962, the process chemicals were modified to Processes E-2 and E-3, but the professional and consumer films had to be processed in separate processes. In 1966, Process E-4, a prehardener-type 29.5 C (85 F) process, was introduced for processing color films such as Ektachrome-X and high-speed Ektachrome films. This new process improved the photographic and physical characteristics of transparencies and reduced the processing time to 47 minutes. The reversal exposure-by-light step was eliminated by putting a chemical fogging agent in the color developer. Now, Kodak Ektachrome professional films, Ektachrome duplicating films, and chemicals for Process E-6 are available.

COLOR BALANCE

Many different light sources may be used for slide duplicating, even diffused window light or daylight. Since most transparency films are available in both daylight and tungsten balances, it will be necessary to correct color temperature with CC filters. These are also useful when correcting an off-color transparency. (See Chapter 5 for more information.)

To maintain the color balance of whatever emulsion you purchase in quantity—whether roll film or bulk—the film should be stored under refrigeration at temperatures not exceeding 13 C (55 F). (Keep in mind that it is easier to repeat a color balance with accuracy when you purchase film in bulk.) These films must be handled in total darkness. To prevent moisture condensation on the surfaces, after removing the film from the refrigerator, allow the package to reach room temperature before opening.

EXPOSING THE FILM

The single-lens reflex camera usually has a built-in exposure meter. The meter compensates for the loss of light caused by bellows or extension tubes. The f-stop marked on the lens is accurate only at infinity, and as the lens is moved further from the film plane, there is a loss of

lens speed. A meter can be used to establish the relative light transmission of the transparency you are photographing. If your camera is not equipped with built-in metering, it will take a bit of experimentation to determine your exposure.

Remember that the degree of magnification is one of the important factors determining correct exposure. When you use extension tubes, long bellows extensions, or any device to move that lens away from the film plane to get magnification, you cannot rely on the f-stop markings on your camera. Each time you change magnification you also change the f-stop. The further the lens is from the film, the longer exposure time you need. Whether you do occasional slide duplicating, or a considerable amount on a regular basis, the only accurate method you have for controlling final results is to make test exposures to determine the basic film speed of the emulsion you are using. The test will also show how the color balance compares to the balance you desire.

In making tests it is important to keep records of your magnifications, lenses, exposure, filtration, and other factors that may vary when you repeat the process. Tests are worthless if you do not keep this data to use as future reference. Tests are only useful when you use the same emulsion-number material, otherwise the test can only be considered a starting or ball park departure point. In most cases you will have to make further corrections.

LAB PROCESSING

If outside facilities process your slides and you send a test to be processed, be certain to send your final slides to the same lab. This will give you the repeatability in processing you are looking for. It would be reckless to use one lab to process a test and a second lab to process your actual films, because there will be considerable variation between one lab and another.

SELF-PROCESSING

The quickest and simplest way to produce high-quality duplicates or rephotography of your slides is to process your own film. With the shortening of the processes today, it is relatively simple to expose film, process it, and evaluate the color film once it is dry. At this time, you can repeat, with corrections, what you have done, and within hours have some good duplicate slides ready for mounting.

CORRECTING BALANCE

Once your tests are dry or have been returned from the lab, studying them on a light box will make color-balance changes apparent. (Of course, you must be aware of the color temperature of the light source in your light box.) By placing CC or CP filters directly over the slides you can determine which ones to use. CC filters are optically flat and intended for use on the camera lens. CP filters are not optically corrected and can soften or degrade the image quality. The latter are intended for use in the light path behind the slide only. When you achieve pleasing color balance, those same filters can be added to the filter pack you use when exposing your original tests, and the duplicate slides can then be made to suit your personal taste. Never try to evaluate slides before they are dry because the water between the layers causes an opacity that will deceive you. If a light box is not available, a slide may be mounted and placed in the projector for evaluation. The filters can then be placed over the projection lens to determine the correct color balance.

There are two evaluations you must make—the density and any adjustment in exposure you require, and an entirely separate judgment for color balance. Never attempt to judge the color balance of your slides when the slides are over- or underexposed. Keep in mind that you are working with *reversal* material and, therefore, if your test is too *dark,* it needs *more* exposure; if it is too *light,* it requires *less* exposure.

BULK-LOADING

Many established photographers practice bulk-loading of film. Probably if cost was the only consideration, they might not bother with bulk-loading. There are many other practical reasons for using film of a single emulsion.

Advantages of Buying in Bulk

The cost is sometimes reduced by as much as 50–60 percent compared to purchasing prepackaged cartridges. Of prime interest is repeatability and predictable results. Anyone who buys the occasional roll or two of film will find variation in the material. This diminishes the possibility of accurately controlling the results.

There are many emulsions available in bulk rolls only, so being able to spool your own cartridges gives you access to films that you cannot buy at the camera shop or local drugstore. If you do buy in bulk, purchase only fresh-dated material directly from an authorized dealer. There are many promoters who sell outdated or repackaged film—some made for the motion picture industry—which can be of questionable quality.

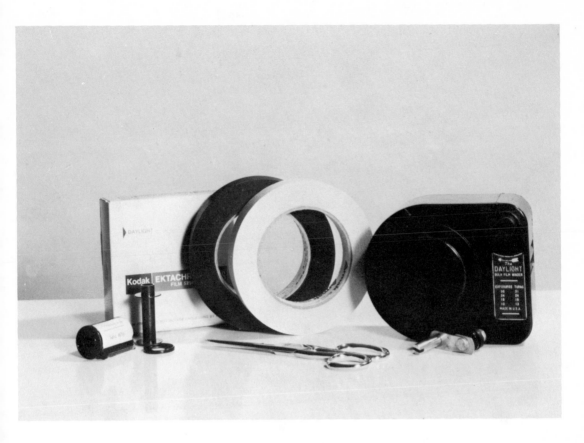

A bulk winder, scissors, tape, and reloadable cassettes are all you require
to bulk load any emulsion.

Equipment for Bulk-Loading

To get started with bulk-loading, the only equipment you require is a bulk loader, a series of reusable cartridges, some masking tape, and a pair of good, round-edged scissors (sharp-pointed shears used in total darkness can occasionally cause bleeding on film). A small investment in purchasing bulk loader and cassettes will pay for itself in a short time. This equipment can be used not only for duplicating film, but for any color, black-and-white, or negative emulsion you use.

Loading bags. It is necessary to make the initial transfer of the film from the package to the bulk loader in a darkroom. For those of you who do not have a darkroom, loading bags may be used instead. These are remarkably handy when carried in your camera case. Should a piece of

Tape is cut into 1½- to 2-inch strips and used to secure the film to the center core of the cartridge.

film tear or the camera jam, you have a portable darkroom wherever you go. The same loading bag can be used to spool film into the tank for processing, thereby eliminating the need for a darkroom during that part of the process. You may purchase the Kodak Snap Cap 35 mm magazines; these are reloadable cartridges. There are others manufactured by a number of companies. Try a few; find the kind that works best for you, then invest in a good supply.

Steps in Bulk-Loading

At this point, the film should be in the bulk loader. (Each loader comes with complete instructions for loading the film into the main magazine.) With practice, this becomes a simple procedure. All other steps are carried out in room light.

Prepare your materials. Organize the empty cassettes, tape, and scissors on a table top. Cut 1½- to 2-inch strips of tape and stick them to the edge of the table where they can be easily removed. You can use either black photographic masking tape or the normal brown masking

42

tape used in painting. If you organize everything before you start, it should take almost no time to load your cartridges.

Determine the number of exposures per cassette. Some of the simple bulk loaders rely on the number of turns of the winding knob to determine how many exposures you will load. Others have counters built in, and some even have an audible click for each frame spooled. You can get approximately eighteen to nineteen 36-exposure rolls from 100 feet of bulk film. This means about 650 exposures on each 100 feet of film, provided you use full-frame 35 mm. Any short pieces left after winding your full cartridges can be used for test exposures.

Remove the cartridge cap. Each cartridge consists of two end caps, both of which come off, but only one is usually removed. Each cartridge has a center core on which your film is spooled, and a casing or shell which protects the film and makes the lighttight container. If you are

The shell of the cartridge is replaced.

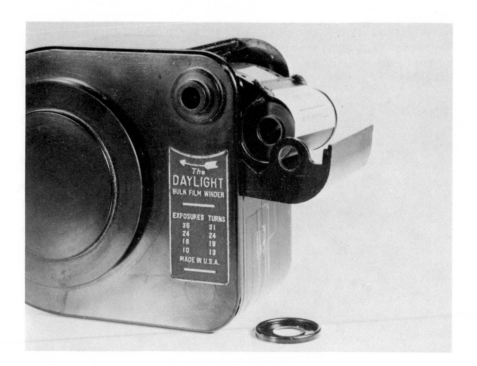

A sharp rap on any solid
surface will open
Kodak's Snap-Cap
cartridges.

consistent in removing the same end, you will quickly get the hang of bulk-loading. By taking the end of the cartridge with the protruding tip and striking the tip against the table, the cap near the palm of your hand should pop off easily.

This cannot be done with manufacturer-loaded cartridges since they are often crimped with a very firm grip. In this case, if you are using a conventional roll film, either a removal device or a can opener will open the cassette. Once the cap is removed, it will be bent out of shape and cannot be reused. Trying to straighten a cap like this or reusing that particular cartridge may cause fogging or other problems on the film.

Kodak's cartridge opener screws down to any surface and facilitates opening crimped cartridges that cannot be opened by rapping them on the table. This sturdy device is inexpensive and built for a lifetime of use. If it is unavailable, an ordinary can opener will suffice.

44

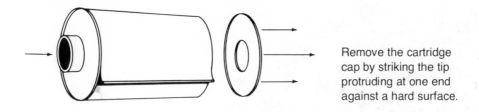

Remove the cartridge cap by striking the tip protruding at one end against a hard surface.

Caution: When you start loading be certain the tape is long enough to hold the film both on *top* and *bottom* to insure that the film will not pull off the center core when you wind it back into the cartridge.

Cut a tongue leader. Once you have spooled your film, you will have to cut a tongue leader on each roll, since most cameras require a leader that is about half the width of the film and about 2½ inches long. Use your scissors or purchase one of the inexpensive tongue-cutting guides available in camera shops.

When the loaded cartridge is removed, a leader must be trimmed so the film may be loaded into your camera.

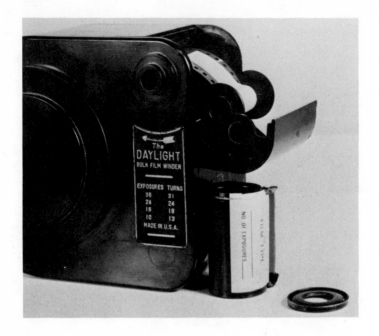

The center core is
secured to the film on
both sides.

Use plastic containers to store the film. Once your film is spooled, each roll should be placed in a vapor-proof container. Small plastic containers that 35 mm film comes in are ideal for this purpose. They frequently can be had for the asking at any photo dealer or camera shop, since they are usually removed before the films are sent out for processing.

Identify your rolls. Each roll that you spool should have identification as to the type of film and the number of exposures. Self-stick tabs— purchased in any stationery store—are handy for this purpose. They can also be removed when you reuse the cassette. A second tab may also be placed on the plastic container so you can identify the film without opening the container.

Refrigerate your containers. These containers can be stored successfully in refrigerators for long periods of time without damage to the film. Remember, refrigerated film will not age nearly as much as unrefrigerated material, and, therefore, the expiration date of the refrigerated film is extended substantially.

46

The cap is affixed, and the cartridge is placed firmly in the loading position.

FILM SIZES

Although most interest in duplication is limited to 35 mm film, it is worthwhile to mention that this same duplicating film is available in larger sizes for producing large color transparencies for decorative, advertising, or promotional purposes. The same process can be utilized by printing the 35 mm original in the enlarger and projecting it to the required size. Ektachrome duplicating film in $4'' \times 5''$, $5'' \times 7''$, $8'' \times 10''$, $11'' \times 14''$, and $16'' \times 20''$ are available in 25-sheet packages. These materials are packaged with instructions for processing and can be ordered through your Kodak dealer. The material is handled very much like any other film product. It can be stored for up to one year under refrigeration, and for considerably longer in a freezer. The freezing puts a halt to any changes in the material and will keep it for an indefinite period of time. The smaller sizes may be processed in trays or stainless-steel film hangers, and the larger sizes in drum processors. Determining exposure and filtration is almost identical to the techniques in conventional color reversal printing. This material is intended to be mounted with a diffusion plastic or glass and illuminated from the rear with fluorescent lighting. There are also small viewers with illuminators that can be used for displaying a smaller transparency. Anyone interested in more technical information on these materials can request pamphlet No. E-58 from the Eastman Kodak Company.

To put a 2-percent exposure on your film before exposing the transparency, take a normal exposure reading of the opal glass or the white cardboard, then reduce this exposure to 2-percent. For instance, if your normal reading is $f/4$ at 1/125 sec., close down approximately 6 stops, keeping your shutter speed constant. If your camera does not stop down to $f/22$, stop down as small as possible and make up the difference in increased shutter speed.

FLASHING THE FILM

Those who prefer regular transparency film for duplicating should be prepared either before or after exposure to produce quality transparencies. This is due to the fact that transparency material inherently has high contrast. Without special preparation, transparencies will be contrasty, have a loss in color saturation, and tend to have a grainy appearance. This can be avoided by flashing the film during or after exposure.

If your camera equipment permits double exposures, you may flash each exposure immediately before or after photographing the slide that you are duplicating. Flashing puts an even exposure of approximately two percent on the film. This reduces the contrast of the material and produces superior slides. Two percent is an approximation for Kodak films. You will have to determine by tests the kind of flash exposure that will work best with the material you are using.

If your camera does not permit double exposures, load your camera and mark a starting point both on the inside of the camera and on the

film. You can quickly run through the roll and put on the flash exposure. Be certain that when you rewind your film you do not draw the leader back into the cassette. Stop rewinding as soon as you feel the tension pull free. The film is again placed in the camera and the advance is used to line up the starting marks. If this is not done, you will have frame lines in your final duplicates. You may then proceed to make your duplicating exposures on the film.

The best way to flash is to use a piece of flashed opal glass with a light behind it. An ordinary 100-watt light bulb works well for tungsten-balanced film. For daylight films, a white cardboard reflector in bright sunlight is best. Focus, and set your camera so you see no image other than the flashed opal glass or white cardboard. Your intention, at this point, is not to put any image on the film but rather a faint base exposure of a pure white background.

With the cover closed, the winder is inserted and rotated the correct number of turns to spool the length of film desired.

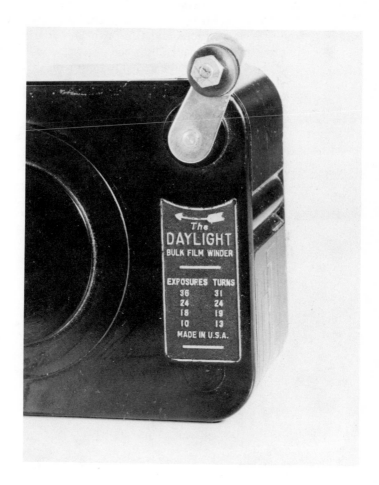

Determining Exposure

Using your exposure meter, determine the correct exposure for the opal glass or white cardboard. You have to reduce exposure 50 times, which means two percent of your correct normal exposure. In terms of f-stops that means 6 stops less than the original exposure, if the shutter speed remains constant. Doing a series of test flash exposures is the easiest approach. There are variations of shutter speeds, lens markings, and films. Make tests with the equipment and emulsion you are going to use. Once you determine the flash exposure that works well for you, you will be able to repeat your results in the future.

Flashing for Effect

Occasionally a slide has a very beautiful composition but is too literal in its representation. For an ethereal effect, a flash exposure can be superimposed over a conventional slide to make a more exciting image. Fabric textures and tints can be superimposed in this manner to improve slides as well. Old wood patterns, walls with rough textures, and brick effects can also be added to your film this way.

Processing

LAB PROCESSING VS. SELF-PROCESSING

The occasional photographer may prefer to use outside lab services to process color film. If this is your choice, have your film processed by the company that manufactured it. For instance, if you use Kodak film, you will get better results by using Kodak processing. The same holds true for other film manufacturers. Almost without exception this processing will give you superior results. A manufacturer's vested interest in producing the best results is your assurance of quality processing. There is no point in sending your films—the result of much effort—to cheap film processors. Many of the photofinishing laboratories that process color film use "house" chemicals (off brand), which are less expensive and do not always produce the quality that the film is capable of when processed as recommended.

Most laboratories make every effort to produce good results. However, to make their processing economically feasible, since they handle huge volumes of film, most laboratories use a replenishing system to rejuvenate their chemistry. This is one instance where the self-processor has the advantage over a lab. Once you are familiar with the processing procedures you can use your chemistry for the recommended period of time and discard it. Using chemistry this way eliminates many of the problems that arise from replenishment systems. If you are a careful worker and use your chemistry for the proper number of films, then discard it, the consistency of your processing will be higher than the processing supplied by outside labs.

For those of you who are concerned with cost, bulk-loading and self-processing will permit up to twice as much photography within the same budget. Of course, the delight of being able to make pictures on a beautiful sunny Sunday and project those slides the same evening is an additional thrill gained from self-processing.

DOING IT YOURSELF

For years many photographers—both amateur and professional—have been intimidated by terrifying and complicated instruction sheets and deadly dull technical data on color film processing. Many laboratories and finishers suggest that it is foolish to waste your valuable time competing with their million dollar, super electronic, razzle-dazzle equipment. They are probably correct as long as all you require is a straightforward, reasonable facsimile of your original transparency. Only expensive custom labs can produce color-corrected, balanced, and cropped slides. However, if you are willing to invest time to learn the process, mix the chemistry, prepare it properly, and use reasonable care, nobody can process color film better than you. In truth, the skills required to process any color films are the abilities to load a film-tank reel, read a clock, a chart, a thermometer, and count to seven. Once you learn this simple method, making your own dupes is convenient and economical. Remember, your aim is quality and control, not economy.

Equipment

Processing does not require a tremendous investment in equipment. If you have a darkroom or loading bag, and a sink with hot and cold running water, you will need only the following inexpensive items:

A developing tank. Any hard rubber, stainless-steel, or plastic tank may be used. While plastic tanks maintain temperature for longer periods of time, stainless-steel tanks are easier for tempering solutions because they transmit heat more readily than plastic. Be certain the tank does not require more than 16 oz. of solution to cover the reel when you use a pint kit of chemistry.

An accurate thermometer. Sometimes thermometers vary 1–2 F. Some have been off as much as 5–10 F. Find an accurate electronic or laboratory thermometer and check yours against it. Find the degree of variation in your thermometer and accommodate for that variation by correcting for the error. That way you will be working at the correct temperature.

A 32-oz. glass graduate, a plastic, or stainless-steel stirring rod, and a glass, plastic, or stainless-steel funnel. Seven 16-, 32-, or 64-oz. dark-glass or plastic bottles. You can use plastic bottles

"Tempor," the talking thermometer, is manufactured by Photo-Therm. "Tempor's" electronic probe quickly responds to temperatures of solutions or water. A pulsing tone indicates high temperature, and a constant tone indicates low temperature. The pitch indicates the degree of difference, while silence indicates correct temperature. "Tempor" is a useful monitor for checking solutions and wash water. If the water-supply temperature or pressure varies, "Tempor" will tell you how to adjust the taps.

Accuracy: Plus or minus ¼ F
Range: 68–110 F
Power: Three "C" cells (included)

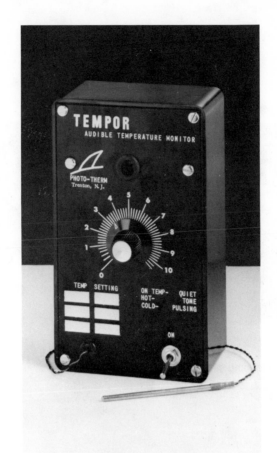

for all the chemistries except the first developer and color developer. These two solutions, unlike the others, have a tendency to oxidize and spoil during storage. Some plastics, though they store liquids adequately, permit air from the outside to diffuse through the plastic into the solution. For this reason, use only brown glass bottles for developer solutions.

A clock or photographic timer. There is little need for super timers with split-second accuracy. Any clock with a large second hand can be utilized. Any of the moderately-priced timers on the market will work equally as well.

Stainless-steel, plastic, or wooden film clips. These are used to hang the film after processing.

Winding Exposed Film onto a Self-Loading Reel

(1) When moist, plastic self-loading reels can bind, making film loading difficult. If the reels are not completely dry, use any conventional hair dryer to drive off dampness and insure easy loading.

(2) Open the cartridge in total darkness.

(3) Remove the shell and trim the leader.

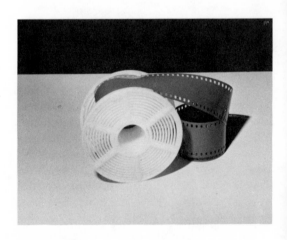

(4) Start the film on the reel until it is past the grippers.

(5) Rotate the reel until the film is almost completely loaded.

(6) Cut the film close to the center core of the cartridge and complete winding.

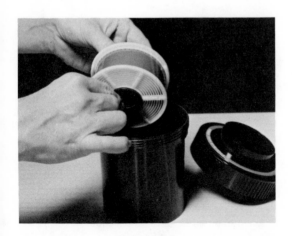

(7) Paterson tanks use a center reel holder. Insert it firmly so the reel seats on the flat base collar.

(8) Make sure the cap is firmly locked before putting room lights on.

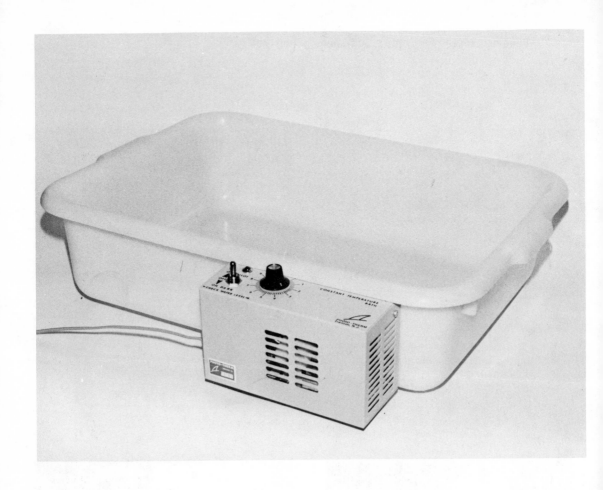

Constant Temperature Bath Model 14—manufactured by Photo-Therm—
consists of a solid-state sensor, electronic controller, circulating pump, stainless-steel
heater, and polypropylene basin. A pilot light indicates when the unit is in the heat
mode, but a switch is provided to turn this light off for darkroom operations. This model
can be used for negatives, slides, and prints. The bath can be a water jacket for film,
paper, and photochemical containers; or its integral pump can be used to circulate
tempered water through external equipment such as a Kodak Rapid Processor.

Range: 68 F to 110 F
Accuracy: Plus or minus 0.1 F
Operating Voltage (voltage dependent): 105–130 v; 50 or 60 Hz

The advantages. With these simple tools you can enjoy the advantages of self-processing. Briefly, these advantages are: you can expose film, process a test, reexpose film, and have final transparencies to suit the balance and density you require all within several hours (the E-6 process offers approximately 30 minutes of wet time); you can process duplicating film, which is specifically made for rephotography, and conventional E-6 slide film in the same tank. By using a tank with a capacity for a number of rolls, you can mix camera and duplicating film in a single processing cycle.

Mixing the Chemicals

If this is your first adventure in color processing, set aside a separate time for mixing your chemicals, and then wait a few hours before starting the process. By separating the mixing and the film processing you simplify each segment.

Prepare suitable bottles and label each one. Note that the two developers are in brown glass bottles. All other solutions store well in plastic containers.

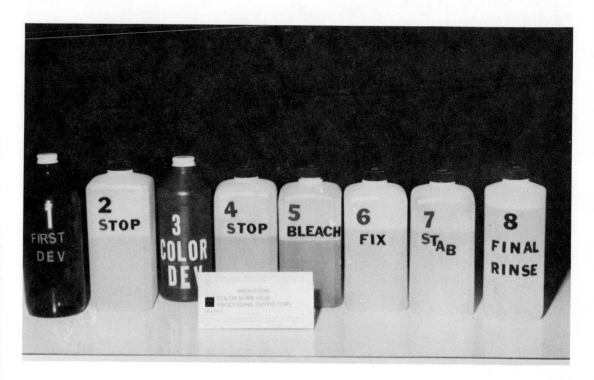

Mixing is a matter of organization. Prepare seven thoroughly washed and labeled bottles. Mark on each label the number of the step and the name of the solution the bottle will contain. Duplicate this marking system on your bottle caps. If caps are intermixed in color chemistry, you can contaminate a solution and ruin valuable film. It takes only one part in several million of the bleach-fix to destroy a developer solution.

Separate your chemical packages and bottles and set them out in sequence. Mix each solution individually. Be certain that the volume of

You can save time by filling a "Tempor" container with water slightly warmer than processing temperature. Place all bottles in the unit and allow adequate warming time.

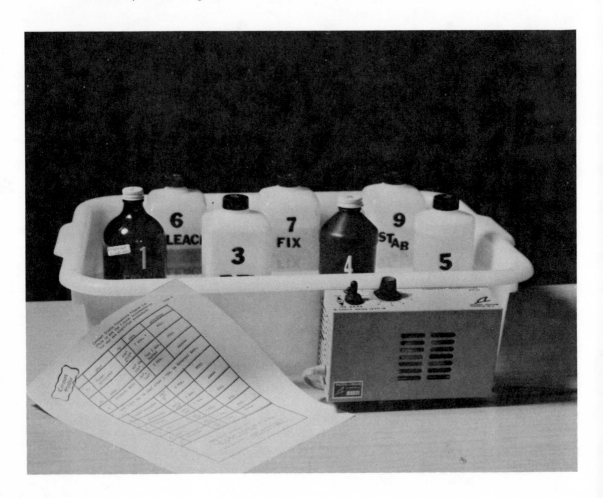

Check the water-bath temperature when the unit's signal light indicates that the water has reached the correct temperature. This does not necessarily mean that the solutions in the bottles have reached the correct temperature.

your bottles is doubly checked. Most pint, quart, and gallon bottles hold more liquid than indicated. Use the graduate to carefully check each bottle's volume. Set the series of chemicals out on a table or counter and organize them. Make sure each is placed in the correct position if more than one bottle of concentrated chemical is needed to mix one solution. If a manufacturer suggests mixing a chemical at a certain temperature, follow those requirements. Read the instructions and proceed a step at a time. After the first half dozen kits, the process will become routine.

E-6 chemistry is simple because most of the solutions are liquid. Merely add the liquid to the correct amount of water. First fill the bottle with a small amount of water. Then add the liquid, adding more water to bring the solution to the correct volume. Mix each of the seven solutions in sequence. Cap and place each bottle in a separate area once the mixing is completed. In addition to the seven steps in Process E-6, there are a number of washes.

Each step is a separate chemical reaction and each reaction is affected by basic conditions. These are:

• The solution strength affects the energy of the reaction.

• Temperature affects the speed of the reaction.

• Time affects the completeness of the reaction. (There is a safety factor in some of the solutions insofar as the time goes. This is because the solutions lose energy as they are used, thereby lengthening the reaction time. The time set for the process is designed to take all these factors into consideration so the quality of the last roll will match the quality of the first.)

• Agitation affects the uniformity of the chemical reaction and the contact of fresh solution with the film's surface. (Major variations in agitation, particularly during the first developer, will also change the activity of the developer and therefore the end result. Agitation should be consistent from roll to roll and processing time to processing time.)

• Washing removes the chemicals that remain in the film after your chemistry has been poured off. Washing also removes the reaction by-products, preventing unwanted reactions in succeeding solutions.

Since the temperature of the first developer is critical, it should be checked *before* pouring it into the tank.

Helpful Hints

Familiarize yourself with all the procedures and steps in the process, but remember there is some latitude permissible. In the first developer and color developer stick as close to the manufacturer's recommendations on temperature and agitation as possible. In the other steps of the process, realize that the solutions such as stop, hardener, bleach, fix, and stabilizer are all designed to work to completion and beyond. If you put film in a stop or hardening bath, the action takes place in less time than allowed on the chart. Once the action has been completed, additional time in the chemistry will not affect the quality of the color slides. You cannot over-stop, over-fix, or over-harden films unless you go to extremes.

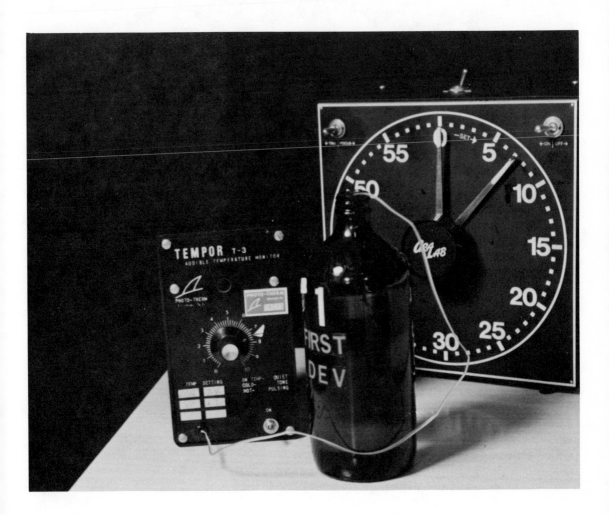

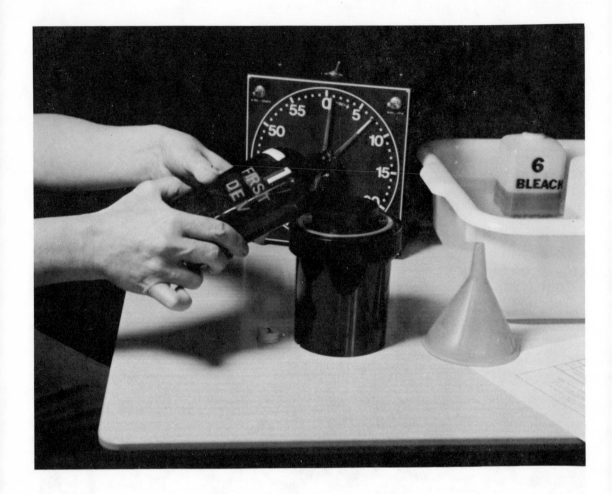

Time and temperature. Care should be used, but let reason prevail. Try to follow the manufacturer's times as closely as possible. But if the phone rings when film is in a wash, extending that wash will have no effect on the film. The temperature recommended for processing by the manufacturer must be adhered to both in the first developer and the color developer. Larger variations are permissible without harmful effects in the other solutions. In most cases, using tap water and approximating the temperature will not affect the process either.

Partial processing. For best results, process exposed color film as soon as possible. If you are on the road where this is not possible, there is a way to protect your films and get an idea of your results. E-6 films can be partially processed after exposure by using a loading bag and a tank.

Preset your timer for the first developer time but do not start it. Quickly pour the correct amount of developer into the tank and then start the timer.

Process the film through the first developer, the wash, and the reversal bath, and at this point, give the film an additional wash of four to five minutes. Then dry it. Carefully store the film in containers.

When you return home, the film can be resoaked and the balance of the processing done by continuing in the color developer, conditioner, bleach, fix, final wash, and stabilizer. At times it is advantageous to use this procedure. Once the film has been partially processed, it is no longer sensitive to X-radiation from airport security devices. Excessive heat can also affect unprocessed film more readily than partially processed film.

Drying. Hang the film to dry in a cool, dust-free area. Attach a film clip to weight the bottom and prevent curling. Because E-6 films are thin-emulsion materials, they dry more rapidly than some of the older films. Close windows to prevent dust-stirring drafts. Force-drying with an electric heater or fan is not recommended unless you utilize a special drying cabinet, which filters the air before it reaches the film.

The solutions. Do not over-work the solutions or use them beyond the recommended time schedules. This can reduce the quality of the finished product.

Manual vs. mechanical agitation. A special word of caution to anyone who owns and uses mechanical agitation devices: Kodak E-6 Processing Pamphlet No. E-37 warns that manual agitation only is recommended for roll films on reels. Films have been damaged or processed defectively by the use of smaller amounts of solutions that were agitated mechanically. In this case, the simplest way to avoid these problems is to agitate by hand.

Aids to Learning

Practice loading the reels. It is important to become familiar with the proper technique for loading a reel. Unless instructions are followed, physical abrasions or uneven development may result, causing streaks or other markings on the film. Loading must be done in total darkness.

If in the past you experienced difficulties loading film on reels, you

If there is no rush, air drying is permitted. This may be speeded up by the careful use of a good film squeegee.

When processing is completed, carefully remove the film from the reel and hang it up to dry.

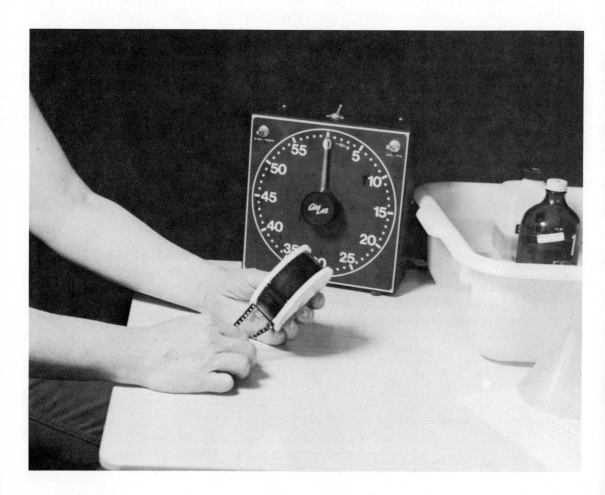

might consider the self-loading reels. Take some unexposed or processed film and practice loading in a lighted area. When you are reasonably proficient, repeat the procedure with your eyes closed. Once you can load the film with your eyes closed, you have mastered the most difficult part of color film processing.

Mount the processing chart. As a guide, cut the chart with the processing times from the instructions and mount it on cardboard. Protect the chart with a clear sheet of acetate or plastic taped over the board. Saran wrap will also protect the chart. Punch a hole in each corner and

hang the chart in the darkroom working area. Check the chart periodically to make sure the manufacturer has not updated or changed recommendations.

Use Kodak processing tapes. As an aid to better self-processing, the Eastman Kodak Company makes processing tapes. These tapes load into a standard cassette recorder and give all the preparation reminders and times for running a specific process. If you feel inclined, make your own processing-time recordings. Sit down with the original instruction sheet and a clock. Before starting the process, remind yourself on tape of any special preparations you may want to make. Give yourself a starting signal. Remember to observe the drain time that is deducted from each step in the process. Following the chart and clock carefully, talk yourself through the process. You might even add a touch of music to suit your own tastes during the longer steps of the process. This tape should be checked after every 20 uses to make certain it has not stretched and elongated the processing time. When starting a new process, it is comforting to have this type of recording telling you what to do and when to do it. Tapes permit you to give full attention to the process without being distracted by the constant need to check instructions.

PROCESS E-6 USING SMALL PROCESSING TANKS

For those of you who prefer doing you own processing, here is a complete set of working instructions for Process E-6.

Materials

You can use all Kodak Ektachrome roll films for which Process E-6 is recommended. Use the chemicals provided in the Kodak Ektachrome Film Processing Kit and the Kodak Developer Kit, both for Process E-6.

Kodak manufactures—in the pint size E-6 materials—a developer kit that contains two one-pint units of first developer and color developer. If you buy the one-gallon kit and break it down to your required size, you will be able to do twice as much film as the developers. Purchase an additional one-gallon first developer and color developer. This doubles

A metal, wooden, or plastic clip placed at the top of the film can be used to hang the drying film on a peg. A clip hung at the bottom of the film prevents curling during the drying process.

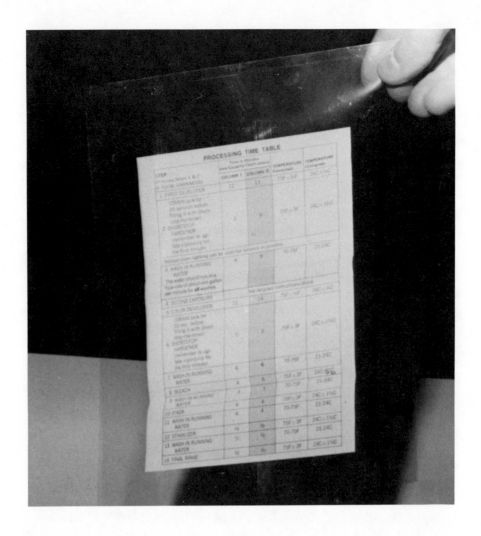

To prevent damage from liquids, trim the processing chart and cover it with acetate before using it in the darkroom.

Kodaword Darkroom Audio Cassettes provide detailed audio instruction for processing several types of photographic materials, including negatives, slides, and/or prints—both color and black-and-white. The tapes include audio timing for all processing steps. Pleasant background music fills in the time between instruction and timing cues. Playback is on conventional cassette tape players.

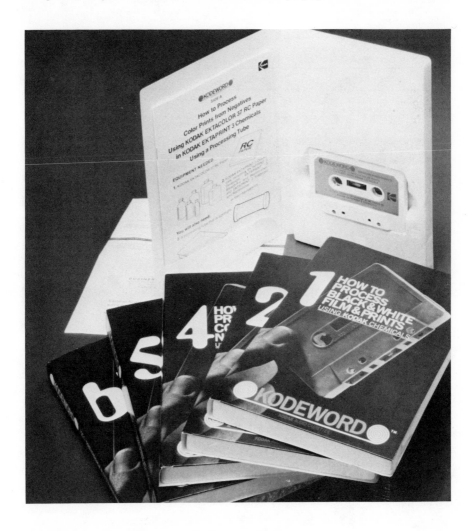

the capacity of the gallon kit without doubling the cost. (See the chart on mixing one-gallon chemicals, p. 72.)

Solutions

For best results, store solutions at normal room temperatures (60–85 F). Do not use solutions that have been stored longer than the following times:

Mixed Solution	Used Solution Stored in Full, Tightly-Stoppered Glass Bottles	Unused Solution Stored in Full, Tightly-Stoppered Glass Bottles
First developer, reversal bath, or conditioner	4 weeks	8 weeks
Color developer	8 weeks	12 weeks
Bleach or fix	24 weeks	24 weeks

Unmixed solutions have a considerably long shelf life.

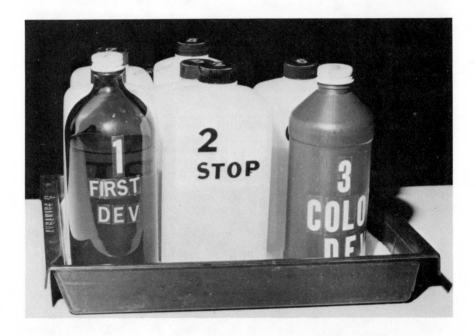

When processing is completed, the entire kit can be stored in a small tray. Be certain to note on the first developer container both the mixing date and the number of rolls of film processed in that kit.

To avoid contamination of the solutions, allow ten seconds of drain time between steps. It is especially important to prevent the fixer from contaminating the first developer, reversal bath, or color developer.

For any given film size, each pint of first developer and color developer will process the number of rolls listed below. *Other* solutions can be used to process *twice* the number of rolls below:

Film Size	135–20	135–36	120–620
Rolls Per Pint	6	4	4

CORONET STUDIO PROCESSING PROGRAM
This is a simplified version of the Kodak E-6 procedure.

	Step or Procedure	Temperature	Time	Agitation
1.	First developer	100 F + 0.5 F	7 min.	Full†
2.	Wash	90–105 F	Two 1 min. washes	Full
3.	Reversal bath*	90–105 F	2 min.	Initial agitation *only*†
4.	Color developer	100 F + 2 F	6 min.	Full
5.	Conditioner	90–105 F	2 min.	Initial agitation *only*
6.	Bleach	90–105 F	7 min.	Full
7.	Fixer	90–105 F	4 min.	Full
8.	Wash	90–105 F	6 min.	Full
9.	Stabilizer	90–105 F	1 min.	Initial agitation *only*

*Room light may be used after 1 min. in the reversal bath.
†Full agitation: Initial agitation PLUS 5 sec. each 30 sec.

For kits of other capacities:

Pint Kit: Add 10 seconds for each roll of 20-exposure 35 mm film. Add 15 seconds for each roll of 120 film and for each 36-exposure 35 mm film.
Quart Kit: Add 8 seconds for 36-exposure, 6 seconds for 20-exposure.
½ Gallon Kit: Add 4 seconds for 36-exposure, 3 seconds for 20-exposure.
Gallon Kit: Add 2 seconds for 36-exposure, 1½ seconds for 20-exposure.

To achieve the maximum processing capacity with a minimum of variation among the rolls processed, increase the first developer time after specific amounts of the film have been processed. Use the first development times below:

First developer time—7 minutes (normal)

Add 15 seconds per 135–36 or 120 roll

Add 10 seconds per 135–20 roll

Solutions that have exceeded their storage life should be discarded regardless of any unused capacity.

E-6 BREAKDOWN MIXING

This is Coronet Studio's procedure and *not* the manufacturer's recommendation. Use exact amounts; if there is some solution left after the last mixing, discard it. Since all chemicals are liquid, it is simple to do.

	Gallon	½ Gallon	Quart	Pint
First developer	24 oz.	12 oz.	6 oz.	3 oz.
Reversal bath	8 oz.	4 oz.	2 oz.	1 oz.
Color developer Part A	25 oz.	12.5 oz.	6.25 oz.	3.1 oz.
Color developer Part B	242 ml	121 ml	60.5 ml	30.2 ml
Conditioner	24 oz.	12 oz.	6 oz.	3 oz.
Bleach Part A	66 oz.	33 oz.	16.5 oz.	8.25 oz.
Bleach Part B	62 ml	31 ml	15.5 ml	7.75 ml
Fixer	474 ml	237 ml	118 ml.	59 ml
Stabilizer	30 ml	15 ml	7.5 ml.	3.75 ml

After four rolls of 120 film, or 36-exposure 35 mm, dump the first developer *and* color developer. Other solutions can be used for twice the number of rolls.

Controlling Temperature

The temperature of the processing solutions must be carefully controlled. Temperature tolerances are given for each solution in the chart of processing steps (p.71). Failure to control temperature within specified ranges will result in variations in density and color balance of the processed transparencies. A recirculated water tempering bath, capable of maintaining the solutions' temperatures within 0.5 F, is ideal for this purpose. If no such device is available, the following procedure may be used:

> Place the solution containers in a deep tray or a sink equipped with a standpipe. Run water at approximately 110 F (56.6 C) into the sink or tray. The water level in this tempering bath should be deep enough to cover at least the bottom half of the solutions in their containers. It may be convenient to load the film onto a reel and place it in the processing tank at this time. Then it will be ready for the first step of the process when the developer temperature is correct.

"Drop-Down" Procedure

Fill the tank with water at 100 F (37.7 C) starting temperature. The tank should contain reels with blank film. Simulate the first developing time and agitate. Check the temperature at the completion of the first developer time. The "drop-down" can be divided in half and added to the 100 F (37.7 C) starting temperature. This will establish an average development time of 100 F (37.7 C) throughout the process without further tempering or water jackets.

Agitation

Use the recommended agitation procedure provided for the type of processing tank being used. Either too little or too much agitation will produce uneven color balance, or other abnormal color or density effects, in the processed transparencies. To insure consistent agitation when only one roll of film is being processed in a multiple-reel tank, the tank should be completely filled with solution and empty reels should be used to fill the tank.

In all processing steps, as soon as the solution has been added to the tank, tap the tank against the table top several times, then agitate for 15 seconds. This is the *only* agitation required for the reversal bath, conditioner, and stabilizer solutions. *Do not* use additional agitation in these solutions.

In the other solutions use a 5-second agitation each 30 seconds of remaining time.

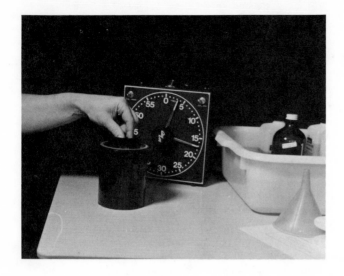

Agitate the film according to the manufacturer's directions and vary your method. Do not over-agitate as this may be as harmful as under-agitation.

Drain Time

The time indicated for each solution *includes* a 10-second drain time. In each step, drain in time to end with process time and start the next step on schedule.

Adjustments for Under- or Overexposed Film

Process E-6 should not be intentionally over- or underexposed. This will result in lower quality, color imbalance, and contrast changes.

Rap the tank sharply on a table top to dislodge air bubbles.

After allowing proper drain time, pour the developer back into the original container. Replace the cap immediately. Repeat this procedure for each step.

To compensate for errors in camera exposure, follow the recommended first developer time adjustments below:

> 2 stops underexposed—increase 5½ minutes
> 1 stop underexposed—increase 2 minutes
> 1 stop overexposed—decrease 2 minutes

Note that this chart is only a guide for emergency use when film has been incorrectly exposed.

Kodak's Process Thermometer Type 3 is a precision instrument used for monitoring temperatures of processing solutions. It has dual scales in both centigrade and Fahrenheit. It is accurate at plus or minus ¼° and measures 12¾".

Temperature. The most critical problems will arise from poor temperature control in the first developer. The other solutions have a great deal of tolerance before they will affect the final results. Use a Kodak color thermometer or an adjustable stainless-steel unit. Check it against a reliable standard and adjust for any error. Certain brand name thermometers can be off as much as four or five degrees in the 100 F (37.7 C) range. This can cause a major loss in color quality. *Check it out and be safe.*

PROCESS PROBLEMS

If the quality of finished transparencies is not satisfactory, use the following as a guide for improving processing:

Problem	Cause and Correction
Light crescents	Kinked film. Load film on to reel more carefully.
Streaks or blotches	Poor agitation. Be sure to use the correct procedure and duration.
Slides too dark	Check camera exposure. Underexposure is the most frequent cause of dark slides. Insufficient agitation, short developing time, or low temperature during first development will also cause dark slides. If this occurs when using first developer second, third, or fourth time, make sure you increase developing time.
Slides too light	Check camera exposure. Overexposure is a frequent cause of light slides. Too much agitation, excessive time, or too high temperature during first development will also cause light slides. Check correct agitation, time, and temperature.
Unusual and unrealistic color balance	Solution contamination. Mix fresh chemistry in thoroughly cleaned bottles. Be sure not to mix bottle caps. Each should be numbered and always put on the same container. Be sure that solutions are used in correct sequence. Number *and* label each bottle.
Slight shift in color balance	Due to storage, slight variations in manufacture, and lens coatings, etc., no two emulsions are exactly alike. Purchase film in quantity (rolls or bulk), and expose a short strip under usual conditions. This will give you a guide to the best ASA setting for that film in your camera and processing setup. If the balance of the film is refrigerated, it will remain stable for long periods of time. You can correct the cast in any emulsion by using Kodak Color Compensating (CC) filters (gels) and cutting them to fit your camera adapter ring. Determine the correction by placing filters over the out-of-balance film until you get the desired result.

Composition: Getting It All Together

PHOTOGRAPHERS AS ARTISTS

The photographer is following in the footsteps of the artist. The painter, however, has had many more years of experience in his art than the photographer in his. The artist quickly learned that those pictures which communicated successfully were constructed intentionally and not by accident. The photographer has learned the same thing. If every shutterbug waited for that perfect "accident" to produce a good photograph, photography would be far less popular today.

COMPOSITION DEFINED

To the beginner, the word "composition" can be overpowering. Each time you point a camera and make a photograph, it's because something you saw triggered a reaction in your conscious or subconscious mind. This something may be beautiful, ugly, exciting, or glamorous. In effect, you are trying to capture what you saw to communicate the reaction you experienced to others who see the photograph. To do this effectively, you must compose each shot before pressing the shutter.

Composition merely refers to the separate elements that when put together make up the story-telling image. The more elements in a photograph, the more confusing and the less impact it will have. The greatest photographs are the simplest and simplicity can serve you well.

Motif

Let's tackle this subject of composition right off by defining a few simple terms. Firstly, every photograph or painting should have a motif. Motif, the French word for motive, when used this way, means the overall

The rule of thirds for motif placement should be used only as a guide. Any prime subject matter placed in the areas where lines intersect—points A, B, C, and D—will be dominant.

theme of a picture. A photograph or painting having a single motif is always stronger and more direct in its communication than one that has several.

The Rule of Thirds

If an effective photograph is to have a single motif, let's determine where the most important part of the picture is placed. Painters discovered a simple rule referred to as the rule of thirds. If the total picture area is dissected into thirds—horizontally and vertically—the placement of the motif will be most powerful at the points where lines intersect (see the accompanying diagram). Not every subject will fit precisely, however, an effort should be made to get as close to these four impact points as possible. For instance, when a horizon dissects a picture the viewer loses interest quickly. However, placement of the horizon line by the rule of thirds will make a far more interesting and dramatic presentation.

Lines

In an attempt to discover the most effective way to organize and design advertising layouts, a group of researchers devised a machine into which a viewer could place his head. Tracking systems in the machine followed the pupils of the viewer's eyes as the viewer studied a layout. Hundreds of people of all ages, sex, and socio-economic brackets were tested. The researchers discovered that in every single case, no matter how many times the experiment was repeated, the viewer's eyes entered the picture at the lower left-hand corner, then moved to the center. Using lines that enter from the left-hand side of the picture permits easy access and, therefore, compels the viewer to stay within the picture area. These tests showed that when lines exitted at the right-hand side of the ad the viewer lost interest. The right-hand side of the picture should be considered the exit area. To hold the attention of the viewer for a longer period of time, try not to let the composition lines exit at the right-hand side. These lines may be a roadway, an arm, or part of a body moving in a

direction. This concept applied to photography shows how to improve a picture by using leading lines in a composition.

Vertical lines. Lines and the direction they move in the composition have a great deal of relationship to the story-telling effect of the photograph. Vertical or upright lines are usually used in monumental subject matter, such as statues, buildings, monuments, trees, cliffs, and mountains. When trying to convey elevation, power, strength, leadership, or dominance, use strong vertical lines.

Horizontal lines. If you saw a picture of a prize fighter in a horizontal position, you would think he was the loser. An aggressive fighter, however, represents diagonal lines that move across the picture. These are lines you will normally see in images representing action. Diagonal lines mean movement, speed, youth, and activity.

Shapes

Often interesting compositions can be obtained by using forms of alphabetical letters. Many compositions rely on the curve or angle of the letters S, A, O, T, M, X, etc. The letter A, or the triangle, is the most common form of composition in art and photography. In portraits, painters discovered that to represent a dominant figure, the form of an

The eye usually enters any illustration at the lower left-hand corner. By supplying a line that leads to the motif, the viewer will immediately see the prime subject.

equilateral triangle was useful in composition. The head balanced and was supported by the base of the triangular shape. In other types of photographs, triangles make exciting composition—the more unequal the triangle, the more interesting the shape. Many Renaissance paintings are composed as a series of repeating triangles. Whenever three heads appear in a painting, or three dominant areas appear in a picture, they are usually considered a triangular composition.

Tones

The eye is attracted to the brightest tones in a picture. Since photographs are two dimensional and most subject matter photographed is three dimensional, the illusion of depth is created in the picture by the arrangement and the dominance of tones. Brighter tones command more attention than darker tones. The use of lighter tones moves the subject forward, while darker tones recede. Tones are also related to each other. In the two accompanying photographs you can see how the middle gray is rendered in two completely different shades, when in fact they represent two pieces of the same gray cardboard. When surrounded by a very bright color, the cardboard tends to appear darker; and when surrounded by a very dark color, it tends to appear lighter.

Strong vertical lines, such as those created by tall buildings, convey the feeling of strength, grandeur, and power.

Photographs of landscapes give the impression of serenity and quiet primarily because they are composed of horizontal lines.

Your pictures will give the feeling of action and force if they are composed of strong diagonal lines.

Surround a light color with a dark background and the light color will
appear dark; surround the same light color with a lighter background and
the surrounded color will appear lighter.

IMPROVING COMPOSITION

Masks

Deciding the composition of your final slide may be simplified by
several tools. Two L-shaped masks when combined will represent the
total picture area. By using these masks, you can determine the most
effective composition for each photograph. Very often, by changing the
magnification, you can take a slide that has distracting elements in it,
remove them, and make a superior composition. (In Chapter 7 there are
suggestions for unusual formats and masks, which are also helpful.)

Framing with Images in Silhouette

A picture can sometimes be enhanced by framing one image with
another image in silhouette. This can add unity and help improve the
picture. In rephotography the silhouette of a tree or any tall structure
photographed against the sky can be combined with scenics. If the propor-
tion is suitable, you can enhance picture quality and improve the compo-
sition of a slide in an interesting and exciting way. One thing to keep in

Yes
No
Yes

Dividing a picture area in half with a horizon line invites the eye to leave the picture. The horizon should come either at the top fourth of the picture or at the bottom third.

mind is that although you are dealing with color slides, a silhouette is black. You can use a black-and-white negative with clear areas to sandwich together with your slides.

Reversing the Image or Flopping the Slide

At times your original scene will be ineffective because it does not move in the correct direction. Rephotography permits you to reverse the image if it enhances the composition. Obviously, this cannot be done when writing or numbers appear in the picture. In most cases, however, a picture can be improved by merely photographing it reversed. View each of your pictures both ways to see if a reversal would improve the slide. As long as you are not doing scientific or police work, where direction is critical, you can use artistic freedom to make changes at will. Notice how the photograph on the next page is improved by reversing the composition. The eye enters and moves directly to the motif more quickly. The eye also remains on the picture longer, making a stronger composition.

Two L-shaped masks, cut to the size of your slides, can help you crop the original slide and improve its composition before rephotography.

The lines in the original photograph (above) fight the eye. By reversing—or flopping—it (right), a much better composition is achieved. Often, an image can be improved by reversing the slide before rephotography.

84

Out of balance

A photograph containing a small, light-colored object and a large,
light-colored object will be unbalanced.

COMPOSING A PORTRAIT

In a portrait, unless you want an unusual effect, it is advisable to
have more space in the direction the subject is looking. The space can be
large or small, as the particular picture dictates. But if the subject's eyes
look out of the picture and there is no space, the viewer will be distracted.

In balance

A small, dark-colored object will weigh down a composition. Balance the
composition by including a large, light-colored object in the photograph.
Similarly, a large, open area can be balanced by including a small, dark
object in the composition.

This high-contrast derivation of a pair of giraffes is interesting, but it is an incomplete composition.

86

Rephotographing the giraffes with a silhouetted tree frames the giraffes and ties the elements of the composition together.

The feeling of tension in the portrait below is a result of the position of the girl's head in relationship to her body.

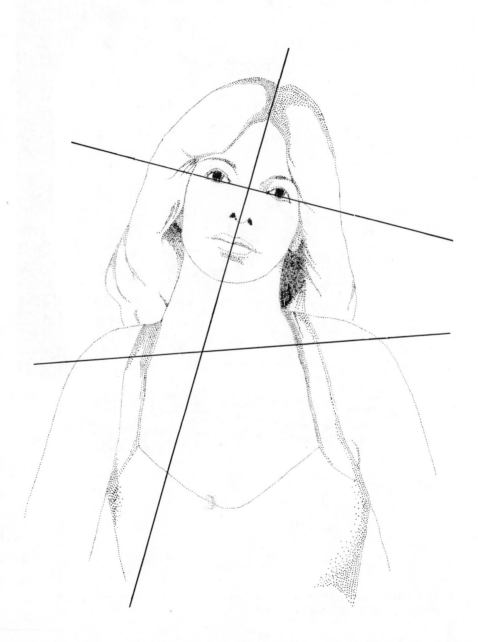

To alleviate this tension, the girl's head has been tipped forward slightly, so the head axis becomes parallel with the shoulder axis.

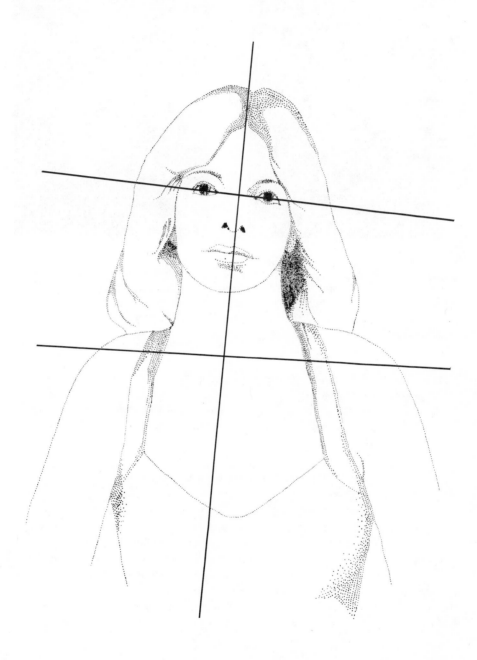

(Left) The position of the girl's head may be dramatic, but because there is more space behind the subject, this composition is disturbing. (Right) Because there is ample space in the direction in which the subject is looking in a more traditional head placement, this composition is more harmonious.

From the start, it is always best to develop the habit of not just centering the object of interest. Instead, take a few moments to study the foreground, the background, and all four corners of the viewfinder. Not only will this improve composition, but it is a more professional approach to picture-taking.

SUBJECT PLACEMENT

The placement of the subject must show movement, either actual or suggested. Lines moving in the direction of the prime subject matter can help suggest this movement. When doing a scenic that utilizes a number of shapes, these must be balanced within the composition so the scene is not overbalanced in one direction. An object that is obviously heavy—in construction or tone—can counterbalance a considerably larger object that is light and airy. This balance is suggested in the accompanying sketches.

90

Improving Your Original Slide

Generally, if you are unhappy with a slide, there are several factors you should consider before making any improvements. Is the slide over- or underexposed? Do the colors communicate effectively? Can the superimposition of an additional slide improve composition or looks?

CORRECTING EXPOSURE

If you have determined that your slide is over- or underexposed, correct for this first. After correcting density, by varying exposure times, all your colors will change. Then you can concentrate on making specific color changes.

You can darken a light slide sometimes up to one f-stop overexposed by shortening the exposure time in development. If your slide is overexposed more than one f-stop, there is little chance of producing a good duplicate. With a combination of chemical treatment and rephotography, slides 2½ to 3 stops underexposed can be considerably improved. (See Chapters 8 and 9.)

CORRECTING COLOR

If, even after the density correction, you are still unhappy with your slide, further corrections can be made by rephotographing it with the proper color filter. If, for instance, you used daylight film in tungsten lighting, certain colors will be off. It is always best to use your color correcting filters when making the original photograph, but when this is not possible, rephotography helps.

Mood can also be improved by adding strong colors and casts. You

Color printing filters come in a variety of colors and are less expensive than color compensating filters. *(Photo by Edmund Scientific Co.)*

can create light airy scenes, or deep somber moods. The more you work with slides and filters, the easier it will be to choose the proper color for a desired effect.

CC Filters

In normal photography it is the CC, or color compensating filter, that corrects for lighting and film deficiencies. If, however, you wish to make the color change after the slide is developed, you can. The CC filter

is optically flat and must be perfect, since it is placed between the slide and the lens. In other words, it is in the direct optical path. Because it must be perfect, it is a more expensive filter.

CP Filters

A similar but less expensive filter used for color correcting is the CP filter, or the color printing filter. This filter is designed for rephotography and enlarging. It need not be perfect, since it is placed beneath the slide. Therefore, even a scratched or soiled filter will not degrade the image on the duplicate.

Both filter types come in an array of colors and densities. For instance, Kodak's CC and CP filters are made in values of .05, .10, .20, and .40. Other manufacturers sell filters in varying densities and calibrations. It should never be assumed that the densities of these filters, even though marked with the same number, are identical to another manufacturer's filters.

Determining the Correct Filter

To determine a color change, you may preview the results by placing the transparency, original or test, in your projector. Then hold filters directly in front of the projector lens until you find one or a combination of filters that gives the desired effect.

As a guide in choosing the proper filter, remember that too much of one color will be neutralized by rephotographing it with its complementary color. So that, if a transparency has an objectionable blue cast or tint, placing the opposite color behind the opal glass when duplicating it will materially reduce or eliminate the tint. In this case, adding a yellow filter will correct the problem. If the transparency is too strong in the yellow coloration, blue filtration will correct it. The color chart (p. 94) indicates that if your transparency is green you can correct it with magenta, the opposite filtration. If it is magenta it would require green filtration. If the transparency is too red, cyan is the correcting color. If the transparency is too cyan, then red is the correcting color.

IMPROVING WITH TEXTURES

In any slide duplicating system, texture can effectively improve the original slide. In selecting texture, it is important to keep the effect from overpowering the original image. A texture should be used only when it complements the image. Try two, three, or more screens on a slide

A color wheel of complementary colors is helpful in determining what filter to use in the rephotography process to block out unwanted colors. For instance, use a yellow filter to minimize blue, a green filter to minimize magenta, etc.

by making a sandwich of the original slide and the screen. Then make exposures through the most pleasing combinations and discard those that appear too strong.

Sources of Texture

Besides using the slides you have built up in your own files as texture screens, you can also purchase screens that are made for this purpose. In addition, several materials that are generally found around the home can be used as texture screens. Any fine-textured, translucent material, such as rice paper, bond paper, or single-ply tissue, will do. As long as you preserve the original slide, you can experiment all you like with different materials and different screens for compelling texture effects. (See the next chapter for additional information.)

6

New Dimensions to Excite the Mind

DOUBLE EXPOSURES

Many of today's single-lens reflexes have a built-in device for making double exposures. Only a few cameras manufactured today do not include this feature. Even if you own a camera capable of making multiple exposures, it is wiser to do this process in rephotography rather than in the original slides. If any error in subject placement is made, or if the proportions or exposures are incorrect on the original slide, there is no remedy. Through rephotography, you can take two separate images and combine them directly or experimentally in a variety of ways. You may elect to change the proportion and amount of exposure for each slide to improve your effects. If your results are not satisfactory, you can go back to your duplicating setup and repeat the process again.

A major advantage of rephotographing a sandwich of several slides is that it eliminates the problem of holding focus during projection. Through rephotography, by closing down the lens, you get both images sharp, and by reducing them to a single new film plane, you will not have any projection problems. You might think in terms of combining an original slide and a conventional black-and-white texture screen to make an unusual effect. Here again by combining the two and reducing them to a single film plane, the results will be superior. This approach also permits reuse of a texture screen or negative as often as desired without purchasing additional screens.

There are several manufacturers who make texture screens (see Appendix). Special care should be taken when using these screens in 35 mm photography. Many screens on a small print will be attractive, but when projected, the magnification of the screen may be objectionable. Before you use screens with slides, mount the screen in a 35 mm mount and project both together to see if the effect is pleasing. This will give you a better idea of how the end product will look, even though it might be

difficult to obtain perfect sharpness for both. The pattern on the screen will have to be very fine in order to work well with a slide. You can also photograph your own texture screens. Sand, rocks, old weather-beaten wood, or a tree trunk make interesting multiple effects. You might start a collection of texture patterns, which you can file and use to combine with other slides. You can even combine a particularly interesting texture pattern in a black-and-white negative with a color slide.

COMBINATION SLIDES

There are a number of ways to make combination slides. If the original slide and texture slide or negative are of moderate density, you can sandwich them together and rephotograph both. With dark slides you may lose the texture in some parts of the image where you want to retain it. In this case you would resort to double exposing the film with 50 percent of the correct exposure. Replace the original film with the texture screen and expose for 50 percent of the indicated exposure. If you wish the screen to be less dominant, you can give 75 percent of the exposure to the original slide, and 25 percent of the exposure to the texture slide or negative. You can try many variations, provided you can manage double exposures on your camera. Some portraits might be improved if they were not razor sharp. In the process of rephotography you can introduce, in front of the lens, some of the devices that will soften and diffuse the image and thereby enhance it. These mood effects can add to the final result. Occasionally for a special effect you may use some of the multi-image lenses, such as those sold by Spiratone, and create new and unusual slides from your original.

Combination Via Dual Projection

If your camera does not permit double exposures (check instruction manual), an alternative method for combining slides, texture screens, or titles is by dual projection. A rigid, translucent screen material made specifically for rear projection is required (for sources see index and Chapter 1). Place the two projectors behind the screen. Exposures for this type of rephotography can be metered directly in the camera with a built-in exposure meter. Image size can be changed by using a zoom projection lens or by moving the projector. If a shift in color is desired, filters or gels can be taped over the individual projector lenses. This method may also be used to add titles to slides. You are limited only by your own imagination.

Altering the mood of a scene by the addition of CC or CP filters is easily accomplished, since you can see the color changes in your camera finder as you add or subtract filters. See Chapter 5 for more information. (*Photo by Dr. Felix Axelrad.*)

The composition of a candid street scene is improved by increasing magnification during duplication. See Chapter 4 for more information. (*Photo by Dr. Felix Axelrad.*)

The composition of this slide was improved by reversing it before it was duplicated. See Chapter 4 for more information. (*Photo by Dr. Felix Axelrad.*)

Duplication provides an opportunity to improve a moderately underexposed slide by increasing the exposure during the rephotography process. See Chapter 5 for more information. (*Photo by C. Chu.*)

Darkening an original slide or adding a warm color can be achieved through duplication. See Chapter 5 for more information. (*Photo by C. Chu.*)

The use of multiple-prism image lenses and special effects lenses during the duplicating process can transform a static picture (above) into one of movement and interest (right) and (below). See Chapter 6 for more information. (*Photo by C. Chu.*)

The first step in creating a distinctly unique visual is to reproduce the original image on Color Key material. The next step is to rephotograph the combination—original slide and Color Key mask. The result is on the following page. See Chapter 7 for more information. (*Photo by C. Chu.*)

The original transparency (left) was printed in contact with Kodalith film. The resulting high-contrast image was then used to produce a tone line mask (below). A combination of the original slide and the tone line (right) shows how visual impact can be intensified. See Chapter 7 for more information. (*Photo by C. Chu.*)

Balancing the incorrect light source of a photograph (left) taken in a museum can greatly improve color rendition. See Chapter 5 for more information. (*Photo by C. Chu.*)

Changing the color
balance of a slide can
better portray the effect
the photographer is
trying to convey. See
Chapter 5 for more
information (*Photo by
William Garlick.*)

(Above and right, opposite) Making multiple exposures on the original film—if your camera has that capacity—can be tricky. The same effects can be achieved more easily by exposing slide duplicates several times or by dual projection. This takes the guesswork out of making multiple images. For more information see Chapter 6. (*Photos by William Garlick.*)

Combining two images (mast and sky) by dual projection allows the photographer to control the magnification of each individual image to produce a new photograph. See Chapter 6 for more information. (*Photo by Mike Q.*)

(Following page.) By duplicating his slides, the photographer can safely store original slides while he uses duplicates to project in presentations, mail to prospective purchasers, or enter in competitions or exhibits. (*Photo by Mike Q.*)

BLACK-AND-WHITE PRINTS FROM COLOR SLIDES

Some photographic applications call for black-and-white prints, rather than color transparencies. Magazines and books, for instance, can print inexpensively if they do not use color. You, yourself, may like the composition of a slide, but not the tonal balance or quality. By reproducing the slide in black-and-white you may obtain a more aesthetically appealing photograph.

Films

If this is your desire, there are many slow-speed commercial films you can use. One of these is an orthochromatic film. Since it is insensitive to red, it can be developed in a red (Series 2) safelight. You can watch the film develop and stop development when the correct density is reached. If the commercial film does not yield the desired results, you can use panchromatic sheet film, which must be handled in total darkness or in a green (Series 3) safelight.

To duplicate by dual projection, you need a special rear-projection screen, two projectors, and a camera affixed to a tripod.

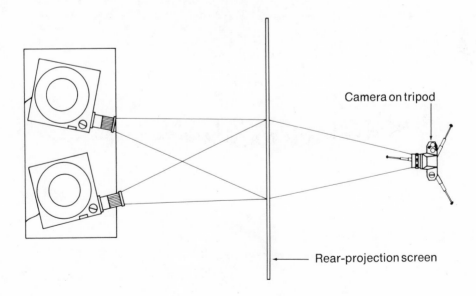

Camera on tripod

Rear-projection screen

This negative, made from a color transparency, was obtained by contact printing on black-and-white sheet film.

Exposure

Project your slide onto your enlarging easel. Your objective is to make a black-and-white negative with a good range of tones. Place a piece of black paper under the film in the easel to prevent halation. If your enlarger leaks light, improvise with black paper or tape. Extraneous light may cause an overall fog on film. It is advisable to make a trial series of exposures on a film in 50 percent increments. Then as you process it, at the recommended time, you can determine which test exposure will suit you.

Placing black paper beneath the film in the enlarging easel will prevent halation when making an exposure.

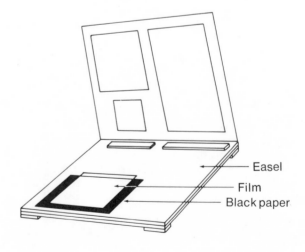

Easel

Film

Black paper

This print was made from the negative on the opposite page.

Development

Develop your film in conventional black-and-white chemistry. Sheet films can be developed in a small set of trays in black-and-white print developer, stop bath, and fixer. Larger size films will withstand handling in print developer such as Dektol (diluted 3:1) or whatever print developer you prefer.

BLACK-AND-WHITE SLIDES FROM COLOR TRANSPARENCIES

When the need arises to duplicate transparencies in black and white, regardless of whether the original is black and white or color, there are a number of methods that may be used. The one you select depends primarily on the number of duplicates you need and the size of the original and finished transparencies. For the occasional user, black-and-white duplicates from color transparencies can be made by contact printing the original on film such as Kodak commercial film, No. 4127, or No. 6123 if the Estar base is not required. These films are available in sizes 4″ × 5″ to 8″ × 10″ and come in 25-, 50- and 100-sheet packages. This film is considerably faster than most enlarging papers, although it is generally thought of as slow in comparison to other films. More information can be obtained from your camera shop.

In cases where you wish to crop the original, your enlarger can be used to project the original image on the commercial film to the desired composition or size. Process the film in standard black-and-white film

developer, stop, and fixer, and handle it as you would any other cut film. Since this material is orthochromatic, a fairly bright red safelight (Series 2) may be used to inspect the film during the processing time.

Exposure, Contrast, and Correction

From the original, either contact print or project a negative. As in any type of enlarging, the exposure must be determined by making test strips. The contrast of your negative, produced by this process, can be controlled. Reducing exposure and increasing developing time will increase the contrast of your negative. Increasing exposure and reducing developing time will reduce the contrast. When the negative has been fully processed and dried, reverse it to a transparency by contact printing or enlarging on the same material with the same processing procedures. The resulting transparency or slide made from the negative is frequently referred to as a diapositive. If correction, art work, or retouching is necessary, expose the original photograph or transparency in a larger size, such as 4″ × 5″, 5″ × 7″, or 8″ × 10″, and make whatever corrections are necessary on the larger film.

From Internegative to Positive

When the negative has been suitably corrected or retouched, it may then be photographed on film such as Kodak Fine Grain Positive film, No. 7302. This is a low-speed, blue-sensitive film that is basically used for making transparencies from continuous-tone negatives. It is extremely fine grained and has very high resolving power. Contrast can be modified over a wide range by development and exposure variations. Back the film by a flashed opal glass and illuminate it from the rear. Since this material is primarily designed to function with a tungsten light source, a simple 75- or 100-watt lamp behind the opal glass will provide sufficiently even illumination to work. Process the film in the same yellow-green 0A safelight or a light red 1A safelight that is commonly used for black-and-white printing. Depending on the contrast, you can tray develop these films in D-76 for low-contrast, Dektol at a 3:1 dilution for moderate contrast and D-11 for high contrast. The film is also manufactured in 4″ × 5″, 5″ × 7″, 8″ × 10″, 10″ × 12″, and 11″ × 14″ sizes, so the final transparency can be of any size.

Using 35 mm Stock

For those interested in the same or similar material in 35 mm stock, obtain Kodak Fine Grain Duplicating Panchromatic negative film, No. 5234 or No. 7234. This material is usually sold only in extremely long lengths, 1000 feet or more on a core, and is not practical for the casual user. However, 4″ × 5″ film can be cut to the correct size under proper safelight conditions for contact printing or enlarging. Full sheet may be

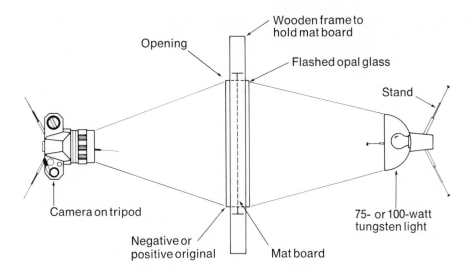

Wooden frame to hold mat board

Opening

Flashed opal glass

Stand

Camera on tripod

75- or 100-watt tungsten light

Negative or positive original

Mat board

Place the corrected internegative in a wooden frame and photograph it on low-speed, blue-sensitive film using a 75- or 100-watt tungsten light bulb.

used to make occasional 35 mm slides. You can use an empty 35 mm slide mount to help you frame the actual image size required.

Direct Positive Processing

A second approach to making black-and-white transparencies from color transparencies is by using conventional Kodak Plus-X film. The variation takes place in the processing. Instead of developing the film in conventional chemistry, it is processed in a special direct positive black-and-white film outfit. This consists of one quart each of first developer, bleach, and clearing bath, plus five one-pint units of redeveloper. Fixer is not included with the kit, however, any standard black-and-white fixer may be utilized. The kit may be found in many camera stores and is listed as catalog No. 123 9714. Load the Plus-X into the camera if you are using a copystand, bellows unit, or slide-duplicating device, or contact print the film by placing the original slide and film emulsion to emulsion. Of course, the transparencies must be removed from cardboard, plastic, or glass mounts before duplicating, otherwise good contact cannot be achieved. Make a series of test exposures with an average slide and process these to determine the correct exposure range. Remember that in a reversal process, whether black-and-white or color, if your final transparency is too light, it is overexposed; if it is too dark, it is underexposed. This, of course, is the reverse of conventional printing or photography.

Use Professional Direct Duplicating Film

A third method for making direct transparencies from color to black and white is by using Kodak Professional Direct Duplicating film, No. S0-015. It is a direct-reversal film used in one-step duplication of continuous-tone black-and-white negatives and positives. Since it is an ortho-sensitive material of medium contrast, it can be handled in a light red 1A safelight with a 15-watt bulb approximately 4 feet from the processing tray. Again, exposures are determined by tests because the actual exposures are almost impossible to predict accurately with your equipment. Kodak recommends, as a sample trial, an exposure time of 40 seconds for a tungsten light source that produces three foot candles of light at the exposure plane. What is unique about this material is that it can be developed in a Kodak developer such as DK-50 at full strength for about seven minutes or in a tray of Kodak Dektol 1:1 for about two minutes. The development times may be adjusted to obtain the desired contrast range. After development a brief rinse in short stop for 10 or 15 seconds and conventional fixing in any of the black-and-white fixing baths is all that is necessary. The film should be washed for 20–30 minutes in running water at 65–75 F. To minimize drying marks, Kodak Photo-Flo or a similar wetting agent may be used. Note that this film does not require any reversal processing or special chemistry. This eliminates the need for keeping special chemical kits on hand. Surprisingly, the contrast range and density of this material produces duplicates, either negative or positive, that are almost impossible to separate from the original material. Direct Duplicating film is supplied in 4″ × 5″, 5″ × 7″, and 8″ × 10″ cut-sheet sizes. This material should be stored in the original sealed package under refrigeration at 55 F or lower and should be allowed to warm to room temperature before opening.

Evaluating Your Film

There is a great deal of control in the contrast of a black-and-white negative. If the lightest area of the slide appears too dark on your negative, decrease exposure either by reducing time or by closing down the lens aperture. If you want to increase contrast, reduce the exposure and prolong development. You have the same control in the opposite direction. If your densest exposure is too light—compared to the original slide—then you require an increase in exposure. If your test is too contrasty, increase the exposure and reduce the developing time. Exposure and development act as a balance and can be used to achieve the desired results with experimentation.

If you have a series of slides to duplicate that are basically similar in density and magnification, determine the exposure for an average slide. Use this same exposure for the balance of the slides. You need not test each slide individually.

Special Effects for Slide Enhancement

CONTRAST MASKS

As you know, each time you duplicate a slide you are moving one step away from the original. Therefore, each generation you develop will have more contrast than the one before it. To obtain slides that are most like the original, it will be necessary to create contrast masks. These are negatives produced on high-contrast film, which allow you to block out certain areas of your slide and expose through others. Then you can make an exposure of the light areas of your slide, and without advancing the film, you can change the contrast mask and make an exposure through the dark areas of your slide. In this way, you can control the contrast of your duplicates.

You can also use contrast masks if you wish to intensify or diminish certain areas of your slides. Rather than obtaining an exact match of your original, you can alter the appearance of your slide for mood, message, or special effects.

Materials for Contrast Masks

To produce contrast masks, both negative and positive, you will need a few graphic arts materials. They are: Kodalith Ortho Type 3 or similar graphic arts sheet film, Kodalith developer (A and B solutions, available in powder or liquid form), a red safelight series or Series 2 for use with the slow orthochromatic film, and a contact printing frame or a proofing frame such as those used for making contact sheets. To achieve good contact, it is necessary to remove the original slide from its cardboard, plastic, or glass mounting. After completion of the derivation you may remount the original in a standard mount of your choice.

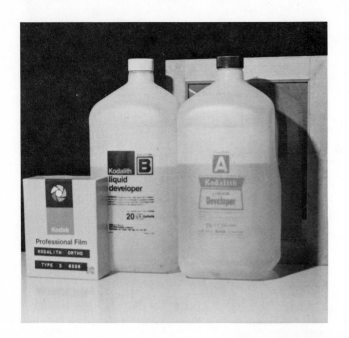

To produce high-contrast masks, you'll need a contact frame, Kodalith developers, A and B, and Kodalith Ortho professional film.

A contact frame, such as this 8″ × 10″ frame manufactured by Premier, is useful not only for contact printing negatives but for making contrast masks as well.

Using an enlarger as a light source, expose the high-contrast film.

Exposure

Place the slide, emulsion up, in a contact frame and put the high-contrast film, emulsion down, over the slide. Clamp the frame shut and place with glass toward the enlarger light source (no negative in carrier). The lens aperture may be used to reduce the amount of light when required. Trial exposures will best indicate the correct exposure for that original.

Development

The Kodalith or similar high-contrast films should be developed in the two-part developer to bring the blacks to total density. This developer is different from conventional black-and-white film developers. For each darkroom session, start with freshly mixed developer. Parts A and B do

not deteriorate when they are stored separately, but upon mixing have a brief life span. Normally, they will last for several hours—just long enough to complete a work session. Developing should be kept to two to four minutes. If you are using orthochromatic film, you can monitor development in a Series 2 safelight. If the films develop in less time, the density in the blacks will not be total. After four minutes the film tends to build a fog level in the clear areas.

Evaluating Development

To evaluate your development, turn your film over when it looks good on the emulsion side. You should see a clear, solid image through the antihalation backing of the film. This will usually indicate that you have adequate development.

Fixing and Washing

After the development, place the film in a standard stop solution for about 15 seconds, then transfer it to a conventional film fixer. When the film has been in the fix for about 15 seconds, you may turn the room

It is imperative to remove the slide from the original mount before attempting any high-contrast mask or other derivations.

lights on. You will find that this film clears quickly, usually within a minute or two. Once the film is completely clear, wash it in cold running water for about five minutes.

Drying

If there is no hurry, the film can be hung up to dry at this time. These films are quite rugged and will withstand considerable handling. After they are washed, they can be lightly squeegeed and dried with a hair dryer. Then you can proceed to your next step or place them in registration with your original camera film.

Registration

Since all the high-contrast masks or titles are placed in registration with the original film, everything has to be done by contact to maintain the same size relationship. When printing these films, you must keep the emulsion of the slide and the emulsion of the film facing one another. If your intent is to increase the contrast of the original slide, contact print your original film on high-contrast material. Once it is dry, repeat this step on a fresh piece of high-contrast film and process it. Place the second film, when dry, in registration with the transparency. It will materially intensify all of the dark areas in your original. This process can be reversed by placing the first high-contrast in contact with your original. This will reduce the contrast of the original film.

Simulating Line Drawings

You can achieve an interesting effect by placing a high-contrast positive and the high-contrast negative together. Contact print this sandwich on a third piece of high-contrast film. This third film is exposed through the edges of the cancelling positive and negative. The contact frame is tilted in order to accomplish this. The frame is rotated at about a 45-degree angle during the entire exposure, which is done using your enlarger as a light source. The resulting film, when you have determined the correct exposure, will be very much like a line drawing. (See accompanying illustration.) When this film is combined with your original slide, it simulates an abstract effect.

Some photographers have other methods of making this angled exposure. Some use a 33⅓ phonograph turntable on which the contact frame is placed. A light is held at a 45-degree angle at a three- to five-foot distance and the exposure is made while the table is rotating.

COLOR KEY

Color Key materials enable you to rephotograph light or dark areas of slides, however, this time your masks will be in colors. Using the proper color, you intensify, diminish, or change colors in a transparency, depending on the effect you wish to produce.

To make a tone line, tilt the contact frame that holds the negative and positive high-contrast masks in registration at a 45-degree angle under the enlarger, and rotate it during the entire exposure. A third piece of high-contrast film—also in the contact frame—will record the fine lines not masked.

Exposure

Exposure of these 3M materials is lengthy compared to conventional photographic materials. It varies considerably with each color in the Color Key set. Tests must be made with each color to determine the correct exposure with your exposing light source. None of the Color Key procedures requires a darkroom, and the film can be handled for brief periods in normal room light without damage.

Development

The development process is rather simple. The film is placed, emulsion up, on a plastic sheet or a sheet of glass. A cotton pad is soaked with the developing solution purchased with the kit. The pad is then rubbed gently over the film to remove excess color. In a few seconds when the image has completely cleared, rinse the negative briefly in cold tap water, pat it dry with a clean towel, and hang it up to dry. Drying time is short.

Trouble-Shooting

If no color adheres to the film after you've processed your first exposure, you have underexposed. Double or quadruple the exposure time. If you process your film and all of the color adheres to it, you have underexposed. Reduce your time until you get the color image that is the reverse of the original film you exposed.

Determining Correct Exposure

An expedient method for determining correct exposure for Color Key (or Diazo materials, which is mentioned next) is to use a 3M Sensitivity Guide. This is a graded exposure scale similar to the Kodak projection print scale but designed for graphic arts materials. It is marked with gradations from 1 to 10. The correct exposure is determined when you retain a solid 4 step in the scale after processing. This will be the correct exposure for any high-contrast film you use. If your light source is constant and the same distance from the film each time you make an exposure, you can note the exposure on the box for that particular color so you do not have to repeat tests.

Registration

Registering these materials is a very simple procedure. The first film you are going to use should be fixed down to glass or a translucent plastic with tape. Any small light source behind the glass permits view-

The notches in the upper right-hand corner of the Color Key materials
indicate that the emulsion side is facing you.

ing through the films. Each color negative is placed over the transparency and moved until registration is achieved. Affix it with tape, layer after layer, until you have completed your sandwich. Registration can be simplified by placing a small magnifying viewer directly over the acetate you are working with. Once you achieve registration, a duplicate slide of the sandwich can be made reducing it to a single-emulsion layer. The same original high-contrast films may be reprinted with a variety of colored gels to determine the most pleasing combination.

When using a small piece of Color Key film, which was cut from the large sheet, clip it in the upper right-hand corner so you will know that this is the emulsion side.

Plug the light into a timer to control the length of the exposure.

A 3M Sensitivity Guide is used to determine the correct exposure for Color Key.

The results of 2-, 4-, 6-, and 8-minute test exposures indicate that 8 minutes is the correct exposure under the light used.

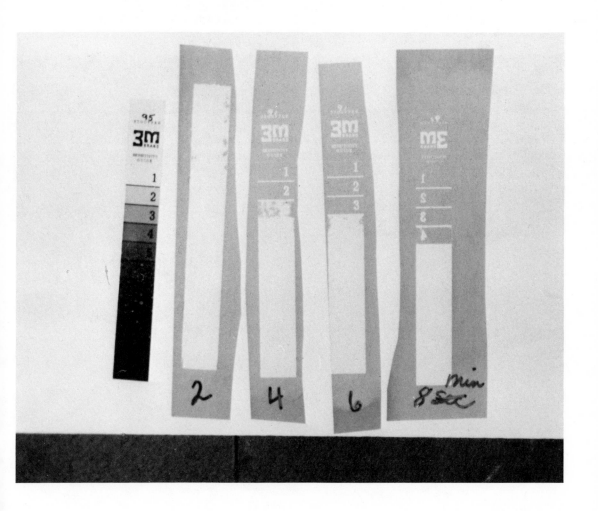

DIAZO

Diazo material is another method of producing color effects from high-contrast Kodalith film. It is supplied in 25-sheet packages, 8½″ × 11″, in each single color you wish to purchase. Consequently, purchasing a series of colors of Diazo materials is a big investment. Diazo material is positive acting. In other words, you get an exact duplicate in tones of the original exposure.

To develop the Color Key, soak a cotton ball in developer solution and rub it gently over the film. Be sure your work surface is clean and waterproof.

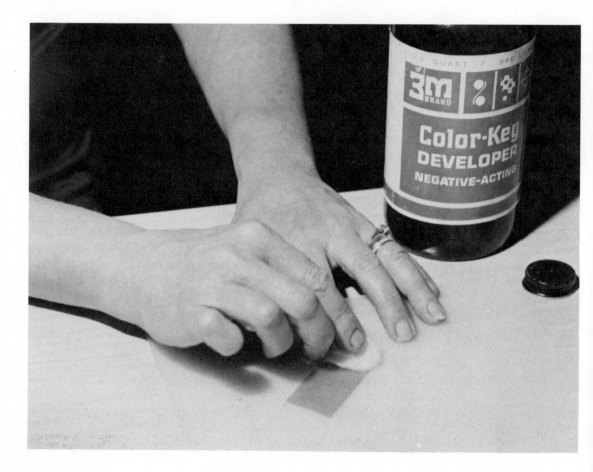

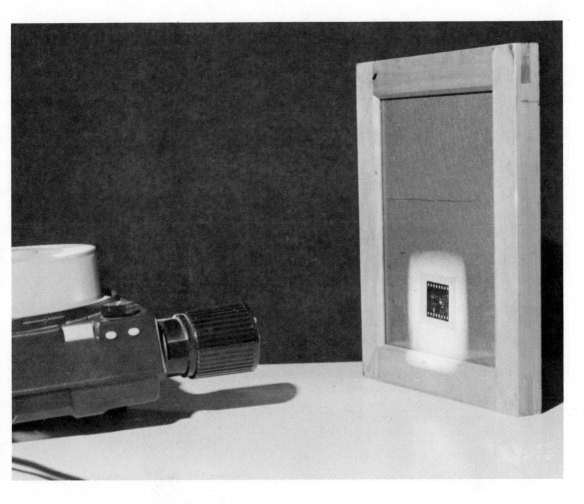

Your projector can be used for exposing Color Key or Diazo materials.

Exposure

The exposure of Diazo material is less critical than that of the Color Key. If, in your first tests, the clear areas have started to darken, this means you have insufficient exposure. If, when processed, the film stays clear and the image does not develop to full strength, this indicates overexposure and the exposing time should be reduced.

Developing

The next step in the processing is entirely different from the 3M Color Key process. You will need a screw-cap jar or glass container, and a

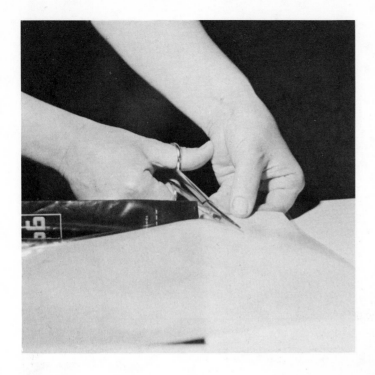

Diazo film is available in 8½″ × 11″ sheets. It can be cut to the size you need. Be sure to notch the cut Diazo so you know which side is the emulsion.

The sponge in the bottom of the processing container absorbs any liquid that may drip from the Diazo materials.

116

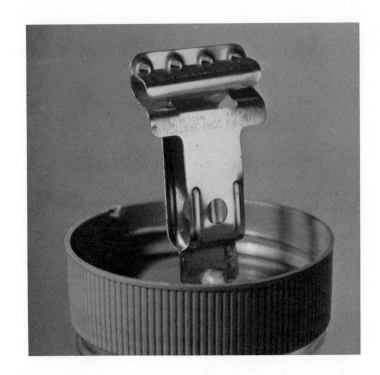

The clip that holds the film out of solution can be any photo clip or spring clip. It must be mounted so as not to interfere with the tight closing of the cap. Any holes made in the cap must be sealed tightly.

Observe the film's processing through the glass container. After about two minutes, the color reaches full saturation and the action stops. These films cannot be overdeveloped.

bottle of commercial ammonia. A clip should be glued or somehow affixed to the underside of the cap of the jar. This clip will hold the film out of the ammonia, since it is the fumes that develop the Diazochromes. Punctures made to affix the clip to the cap should be sealed well so the ammonia vapor will not escape. Since ammonia has an extremely objectionable odor and is quite powerful, it should be used only in a well-ventilated room or outdoors.

Once the film is attached to the clip and the cap is closed tightly, the container may be placed in a small tray of hot water (105–130 F) to accelerate development and give you most saturated color in a brief time. The color takes a minute or two to develop. Once it has reached the full saturation for that particular color, the action stops.

Once the film is processed and is quickly removed from the tank, it is totally dry and ready to use. It can be used immediately without the washing and drying steps required in the 3M process. Because Diazo material is sensitive to ammonia vapors, it should never be exposed and stored in the same area that you do your processing as this will deteriorate the film and desaturate the color.

Combinations of Color Key and Diazo materials can be very interesting. One acts in a negative manner and the other in a positive manner. Diazochrome films are manufactured by a large number of different companies. Your best bet is to contact a local graphic arts distributor and find out which materials are most readily available in your area.

8

Dye Retouching

The Photographic Society of America sponsors an annual photographic exhibit. Exhibitors in these competitions are serious and the competition is keen. To improve their slides exhibitors frequently retouch and correct color slides using the same methods as professional photographic retouchers. As long as the corrections are on slides intended for projection, the visual correction should be perfectly acceptable.

Dye retouching refers to the *addition* of color to the original film. It is possible to *remove* density from a black-and-white print or negative with an etching knife. But because the emulsion of color film is made up of three layers, it is difficult, if not impossible, to remove color this way without changing the color balance. For instance, if you attempt to remove a black spot on a color slide with an etching knife, you would remove the top layer of the emulsion and leave a blue spot. If you continue etching and remove the second layer, a cyan spot will remain. This is because the cyan layer is closest to the base in the construction of the emulsion. Removal of a dark spot can only be accomplished with a chemical bleach that will reduce all three layers equally. If reduction results in a lighter area, dye is applied to build the transparent spot up to the matching density of the surrounding areas. This type of retouching requires an expert retoucher and is generally beyond the skill of the inexperienced. However, when it comes to the addition of dyes to a transparency, there are many procedures a novice can handle.

Prior to retouching an area with dry or wet dye it helps to view the transparency with a CC or CP filter in order to determine which color will closest simulate the desired results. A set of these filters can be extremely handy when a color is to be muted or neutralized and you are not certain which color should be added to produce the desired results. Obviously, if you need a blue sky or greener grass, it is easy to select the appropriate color. If you wish to mute a bright red sweater or neutralize a blue shadow, a quick check through a filter instantly shows which color will be most effective. With both the Kodak color retouching dyes and Liquid E-6 retouching dyes, the match of the colors with Kodak CC or CP filters is quite accurate.

A set of Kodak Print Viewing Filters (No. R-25) is excellent for assisting in the selection of dyes to use to achieve proper color balance.

DRY DYES

An effective method of adding color to broad areas, such as blue or cyan to a sky, or colors to brighten or darken clothing, is with the dry dye technique. This involves the use of Kodak retouching colors. They are sold in jars of wax-based dyes that match the dyes used in emulsions.

Softening the Cakes

When using the Kodak color retouching dyes in the dry cake form, you may experience difficulty due to the hardness of the dyes. The working quality of the dyes can be improved by first placing the dyes on a stove

120

top on a cookie sheet or any shallow pan. With the covers of the jars removed, warm the dyes over a very low flame until they liquify. As soon as they have turned liquid, add 7 to 12 drops of glycerin to each of the colors except the reducer. Mix each color with a separate toothpick to distribute the glycerin evenly throughout the dyes. The moment the glycerin has been well-mixed into the dye, the jars should be removed from the heated surface to cool. Upon cooling, the dyes will solidify into a cake. This makes the dye easier to apply.

Methods of Application

These colors are best applied with cotton swabs or tufts of cotton wrapped around the end of a toothpick. Spread the dye over the area to be corrected. Two, three, or more colors may be applied directly on top of one another to achieve the desired color. These dyes may also be applied repeatedly to build color. If you cannot obtain sufficient color in a single application, set the dye with moisture by carefully breathing on it for a few seconds and permit the film sufficient time to dry. The process may be repeated until you achieve the desired result. In this way, a considerable amount of color can be added to an area that was totally clear.

Methods of Removal

Prior to setting (breathing on the dye), the dye is easily removed by rubbing with a cotton swab or Q-tip. If an area has been treated with dye and set, the dye can be partially removed by using a 14-percent solution of ammonia water. After applying the ammonia water and removing dye, the area should be wiped with cotton moistened in plain water.

If there is an overlap into an area you do not want retouched, the unset dye may be removed with a clean, dry cotton swab. To smooth out rough areas, blend with a small tuft of cotton. Beware of getting moisture on the transparency at this stage because moisture will set the dye and can cause streaking and spots. Although it is permissible to breathe on the cakes of dyes to soften them, you should avoid using a wet brush or any liquid on these dyes because, again, this will cause problems, and the dyes will set prematurely when applied. A reducer, which comes in one of the containers with the dye, will remove a quantity of the dye when too much has been applied. You may also remove unset dye with a cotton swab and denatured alcohol. (Use of alcohol with water in it *must* be avoided.)

Setting the Dyes

Once you are satisfied with your results, set the dye by steaming. Steam from a vaporizer is ideal for setting the dyes permanently. This can also be done by breathing on the dye several times. The color will set and absorb into the film.

WET DYES

The Kodak color retouching dyes can also be used as wet dye. Take a razor blade and cut a small piece of the dye. Place it in a small bottle. Add just enough water to dissolve it and make a fairly strong color. These dyes may be applied with a soft brush on an overlay of commercial film that has been fixed, washed, and dried. (See Overlays for more information.)

PENCILS

Colored-pencil retouching is the simplest approach to correcting a color transparency. In order to work directly on the transparency, the application of a retouching medium, such as Kodak retouching fluid, to

Before using a retouching pencil, make sure about 2½" of lead protrudes from the lead holder.

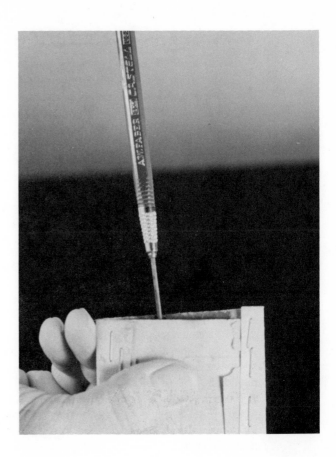

To sharpen the lead, form a pocket of very fine sandpaper, folding and stapling it on three sides so it will hold the graphite powder. Applying light pressure between the thumb and index finger helps taper the point.

the base or shiny side of the transparency is required. It is evenly applied with a cotton swab or tissue. This will put a "tooth" on the base side of the film. Without this fluid, very little color would be retained. Once the film is thoroughly dry, moderate retouching can be done with colored pencils such as Eagel Prismacolor or Eberhard Faber Colorama pencils. Any colored pencil available in art stores can be tested on a piece of film to find out how well it applies. The pencil is sharpened to a fine tapered point and applied carefully to the base side. Applying it to the emulsion side may damage the transparency. If color does not go on smoothly or it streaks, the retouching may be removed with good quality denatured alcohol. When you have added color to an area that still lacks density, an ordinary soft black lead may be applied very lightly over the retouched area until matching density is achieved. Because the previous application of colored pencils weakened the "tooth," only a small amount of the soft black lead will take on this surface.

OVERLAYS

If extensive retouching is needed, whether you use pencil, wet dyes, or dry dyes, the safest procedure is to place an overlay on the emulsion side of the film. This overlay, once taped down, can be worked on readily, and if there is a problem with the retouching it may be removed and replaced with no danger to the original transparency. The best materials for preparing overlays are fixed, washed, and dried commercial film or matte acetate material. The latter is available through art stores. Matte acetate has no grain pattern and has a surface that accepts retouching well. Its trademark is Tuffilm, No. 197-300, manufactured by the Grumbacher Company. Tuffilm, unlike the commercial film, requires no retouching medium prior to the application of colored pencils or dyes.

SLIDES USED FOR PHOTOMECHANICAL REPRODUCTION

One notable exception in dye retouching is that slides used for photomechanical reproduction (slides that are reproduced via separations from the original transparency) must be treated with special dyes. The use of other dyes may cause serious color changes. (Some color dyes do not reproduce the same as they appear.) A special set of dyes is manufactured by Kodak intended primarily for photomechanical reproduction or duplicating. Information on this product can be obtained directly from the manufacturer.

9

Chemical Corrections

In the case of a slide in need of a total color balance change, chemicals provide an alternative to rephotography with filters. The chemicals are absorbed into the emulsion of a transparency and thus become a more permanent change than dye retouching. For some chemical corrections a darkroom is not necessary. For Process E-6 Ektachrome Retouching Dyes, not only a darkroom, but extreme care is needed to mix and apply them. In addition, these chemicals afford the photographer the ability to bleach unwanted dark spots on a slide without affecting the rest of the transparency.

STARER EMULSION DYES

These dyes furnish a simple system for altering the color balance of processed Ektachrome transparencies. No darkroom is necessary. The transparency is dipped into a working solution of the proper dye until the desired color balance is achieved. It is quickly rinsed and dried normally. Restabilization is not necessary but can be done without affecting the new dyes. The kit consists of three dyes (magenta, yellow, and cyan), which are matched organic compounds. These dyes are quickly absorbed into the emulsion to create an immediate color correction. Prolonged exposure tests to direct sunlight have indicated that these dyes are more stable than those contained in emulsions and less affected by ultraviolet radiation.

Procedure

1. Prepare a working solution of each dye by diluting 12 drops of dye in 100 ml of water. Measure with an eye dropper or pipette.

2. Immerse the transparency in a working solution of Photo-Flo or a similar wetting agent for 15 to 20 seconds and allow to drain for 20 seconds.

3. Immerse the transparency in a working solution of proper dye color for 20 to 30 seconds. Rinse briefly in clear tap water (five seconds) and evaluate the color correction. In evaluating color, use a light source similar to the one you will use for final viewing.

4. Evaluate color by using Kodak Rapid Fix (Part A), undiluted, to remove blue opalescent haze from the wet emulsion. If greater color correction is desired, wash off the fixer, redye, print, and reevaluate.

5. When satisfactory color balance is achieved, the slide may be air dried without further treatment.

6. A 10-second immersion in dye working solution will give a .085 color correction and all .025 neutral density.

7. Do *not* discard the working solutions after use. The dyes are durable and can be used over and over. Eventually the dyes will be diluted with Photo-Flo and water carried on the emulsion from prewetting. Add three to four drops of concentrate from the kit bottles to restore the working solution.

8. All color-judging and evaluation must be done on a wet emulsion. Once the emulsion has dried, the dyes cannot be removed.

9. If you have over-corrected a transparency, excess dye must be removed *before* drying. Forty percent of the dye can be removed with a 4-minute wash in running water, 80 percent can be removed in 20 minutes. Twenty percent of dye is residual and is unremovable.

Color Evaluation

View the print or transparency through Kodak viewing filters to determine what improvement can be made to overall color balance. Kodak Rapid Fix (Part A), undiluted, will clear blue opalescent haze from a wet emulsion and render the color balance equal to a dry emulsion for color-judging. Do not dilute the rapid fix. Undiluted ammonium thiosulfate (rapid fix) will not penetrate the emulsion and can be rinsed off with a brief immersion in running water (five seconds each side).

Color Correction

M=magenta	Y=yellow	R=red
C=cyan	B=blue	G=green

M dye removes G color
G dye removes M color
C dye removes R color
R dye removes C color
B dye removes Y color
Y dye removes B color

G=C+Y	B=M+C	R=M+Y

Use of Dyes for Spotting

Allow a small quantity of dye to evaporate on a glass plate. Apply the dry residue by the dry-brush technique.

Adding Neutral Density

Mix M, C, and Y dye in equal amounts into a single solution and immerse the transparency for 30 seconds. One-half stop neutral density will be added for each immersion. Dry emulsion between immersions. Do not attempt correction beyond ten percent. On pastels, a five percent change is usually sufficient. One kit used at the recommended dilution is sufficient to process over 1000 slides.

RETOUCHING KODAK EKTACHROME TRANSPARENCIES, PROCESS E-6* (WITH KODAK E-6 TRANSPARENCY RETOUCHING DYES)

Kodak Ektachrome Films for Process E-6

Kodak Ektachrome Films for Process E-6 are manufactured with a hardened gelatin emulsion for high-temperature processing and have bleaching and retouching characteristics that are different from those of

*This section is supplied courtesy of the Eastman Kodak Co. and contains information regarding the bleaching and dye-retouching of Process E-6 transparencies. For additional procedures, refer to Eastman Kodak Company's Retouching Color Transparencies No. E-68. © 1977 Eastman Kodak Company.

other Kodak color transparency films. Because of the hardened emulsion, the selective bleaches, the total bleach, and the dye application may work more slowly. Increased retouching productivity can be achieved by carefully following the instructions regarding the use of Process E-6 Retouching Dye Buffer. As with all new or unfamiliar photographic processes, it is essential to make tests on discarded material in order to develop an effective technique before attempting any corrections on a valuable transparency.

Bleach Formulas and Instructions for Process E-6

Kodak Total Dye Bleach SR-30. SR-30 stock solutions are stable and can be prepared in advance. Do not use or store in metal containers.

Stock Solution A

Water: 60–80 C (140–176 F)	350 ml
Potassium permanganate	50 grams
Water	600 ml

Completely dissolve the permanganate crystals in the hot water before adding the cool water.

Stock Solution B

Water	900 ml
Sulfuric acid (concentrated)	50 ml
Sodium sulfate	115 grams

Warning: Always add concentrated sulfuric acid to the water slowly, stirring constantly, and never the water to the acid; otherwise the solution may boil and spatter the acid on the hands or face, causing serious burns.

Add the sodium sulfate to the solution, while stirring constantly to prevent caking.

Combine equal quantities of stock solution A and stock solution B. Discard when the combined solutions turn brown.

Do not mix or store in metal containers.

128

Bleaching spots. Objectionable dark spots on Process E-6 Ektachrome transparencies can be bleached with Kodak Total Dye Bleach SR-30 as follows:

1. Apply the total dye bleach to the dark spot with a brush. Let sit for 30 seconds or less. Extended treatment will produce very little additional bleaching and may cause excessive stain and damage to the emulsion.

2. Apply a 5-percent sodium bisulfite solution for approximately 1 minute, or until no color change occurs. (To make a 5-percent sodium bisulfite solution, add 50 grams of sodium bisulfite to 450 ml of water.) It is not necessary to remove excess total bleach solution before applying the 5-percent sodium bisulfite solution.

3. Rinse the area with two or three water applications to remove the sodium bisulfite solution.

4. Repeat Steps 1 through 3 until the desired change in density is attained. The final rinse step (No. 3) should be extended to four or five applications.

Bleaching large areas. Kodak Total Dye Bleach SR-30 can be used to remove the dye from relatively large areas of Process E-6 Ektachrome transparencies as follows:

1. Apply a liquid frisket material (such as Photo Maskoid—red or clear) or careful application of several coats of rubber cement to the areas of the emulsion side of the transparency which are to be retained. Be sure that all such areas are thoroughly protected.

2. Immerse the transparency in a tray of Kodak Total Dye Bleach SR-30 solution for 30 seconds with constant agitation. Drain for 5 to 10 seconds. (Do not wash with water at this step; eventual emulsion damage may result.)

3. Immerse the transparency in the 5-percent sodium bisulfite solution, with agitation, for approximately 1 minute or until no color change occurs.

4. Wash the transparency in running water for 30 to 60 seconds.

5. Repeat Steps 2 through 4 until the desired change in density is attained. A residual image, visible when the transparency is wet, may become invisible when the transparency is dried.

The final wash should be extended to 5 minutes.

Warning: These are dangerous chemical solutions; avoid contact with skin or eyes. Maintain all solutions and washes at 18–27 C (65–80 F).

This procedure should give satisfactory results in most cases. However, if the transparency contains high-density areas adjacent to low-density areas, and if no residual image can be tolerated after bleaching, the following alternative steps will produce additional bleaching action:

1. Prepare Kodak Total Dye Bleach SR-30 stock solutions A and B using distilled or deionized water.
2. Use a fresh solution of 10 percent sodium bisulfite after each bleach treatment.

Selective Bleaches

Kodak Cyan Dye Bleach SR-31. Mix SR-31 Bleach fresh and discard it after 48 hours.

	Tray Use	Brush Use
Water	1 litre	200 ml
Sodium acetate, desiccated or anhydrous	22 grams	22 grams
Sodium Dithionite (Pract.) (sodium hydrosulfite) (Cat. No. P533)*	1.5 grams	1.5 grams

Warning: This is a flammable solid; it may ignite if allowed to become damp. Keep containers tightly closed. Store in a cool, dry place.

Kodak Magenta Dye Bleach SR-32. Mix SR-32 Bleach fresh and discard it after 48 hours.

*Kodak Organic Chemicals can be obtained only from laboratory supply dealers. To avoid delay in shipment when ordering chemicals by mail, include the statement, "This chemical will not be used for drug purposes or sold by us for such use."

	Tray Use	Brush Use
Water	1 litre	200 ml
(Ethylenedinitrilo) tetraacetic		
Acid Disodium Salt	1 gram	1 gram
(Cat. No. 6354)*		
Stannous Chloride (Pract.)	10 grams	10 grams
(Cat. No. P435)*		

Dissolve the chemicals in the order given.

Note: Old or impure stannous chloride may not dissolve readily. If necessary, grind it to a fine powder. Discard any undissolved residue.

A white precipitate, which forms in this solution, is extremely difficult to remove from the film once it has dried. Therefore, wipe the film with a clean viscose sponge while it is immersed in the wash.

Kodak Yellow Dye Bleach SR-33. Mix SR-33 Bleach fresh for each use and discard any unused portion.

	Tray Use	Brush Use
Water	900 ml	200 ml
Sodium chloride	approx. 180 grams	0
Kodak Total Dye Bleach SR-30,		
Stock Solution A	5 ml	5 ml
Kodak Total Dye Bleach SR-30,		
Stock Solution B	10 ml	10 ml

The sodium chloride can be measured as one full measuring cup, or one full 250 ml beaker. Common table salt can be used.

Warning: Do not use sodium chloride, or table salt, with a higher concentration of Kodak Total Dye Bleach SR-30 Stock Solution A (potassium permanganate), because toxic chlorine gas, which is hazardous if inhaled, will be released.

Do not use or store Kodak Yellow Dye Bleach SR-33 in metal containers.

Follow the bleach with a treatment of 5 percent sodium bisulfite solution and then a wash to prevent staining.

*Kodak Organic Chemicals can be obtained only from laboratory supply dealers. To avoid delay in shipment when ordering chemicals by mail, include the statement, "This chemical will not be used for drug purposes or sold by us for such use."

Kodak Yellow Dye Bleach SR-34. Mix SR-34 Bleach fresh for each use and discard any unused portion.

	Tray Use	Brush Use
Water	1 litre	200 ml
Chloramine-T (Cat. No. 1022)*	10 grams	10 grams
7 percent acetic acid solution	Add by the drop, stir, until a definite cloudiness persists	

To make 1 litre of 7 percent acetic acid solution, add 70 ml of glacial acetic acid to 930 ml of water or add 250 ml of 28 percent acetic acid to 750 ml of water.

Warning: Inhaling or allowing skin contact with the dust of chloramine-T is extremely irritating. When it is dissolved in water, chlorine gas is released, which is also hazardous if inhaled. All skin and eye contact, or inhalation of gas, must be prevented.

Caution: Add the acid to the water, never water to acid.

Do not use or store Kodak Yellow Dye Bleach SR-34 in metal containers.

Kodak Red Dye Bleach SR-35 (removes both magenta and yellow dye). This solution can be prepared in advance.

	Tray Use	Brush Use
Water	900 ml	Not
Sulfuric acid (concentrated)	150 ml	recommended

Warning: Always add concentrated sulfuric acid to water slowly, stirring constantly, and never the water to the acid; otherwise, the solution may boil and spatter the acid on the hands or face, causing serious burns.

Use rubber gloves for preparation and tray use.

Brush use is not recommended for Kodak Red Dye Bleach SR-35 because of danger to health and property.

Applications of Kodak Red Dye Bleach SR-35, followed by Kodak Cyan Dye Bleach SR-31, will have an overall bleaching action.

*Kodak Organic Chemicals can be obtained only from laboratory supply dealers. To avoid delay in shipment when ordering chemicals by mail, include the statement, "This chemical will not be used for drug purposes or sold by us for such use."

Kodak Dye Regenerating Solution RG-1. This solution can be prepared in advance.

	Tray Use	**Brush Use**
Water	1 litre	200 ml
Potassium ferricyanide	5 grams	5 grams

Use for up to five minutes to regenerate either cyan or magenta dye that has been overbleached. However, this regeneration method does not apply to magenta dye that has been bleached with Kodak Red Dye Bleach SR-35.

General Bleaching Instructions

To promote uniform bleaching action, prewet the area for approximately one minute with water containing a few drops of Kodak Photo-Flo 200 Solution. The quantity of Photo-Flo 200 Solution depends upon the quality of the water, the film cleanliness, and individual preference. Uniform bleaching action also requires constant agitation of the bleaching solutions in various directions on the working area of the transparency.

All the bleaches are more easily controlled and are more selective in their bleaching action when they are used at 24 C (75 F). For instance, Kodak Magenta Dye Bleach SR-32, when used at 24 C (75 F), removes only magenta dye. At 38 C (100 F), an equivalent amount of magenta dye is bleached in a shorter time, but a significant amount of cyan dye is also removed. The choice of bleaching solution temperature will affect the time required for bleaching, the ease of bleaching control, and the selectivity of the dyes bleached.

All of the selective dye bleaches, with the exception of Kodak Red Dye Bleach SR-35, are unstable, particularly when they are exposed to air at high temperatures. Also, they are exhausted after treating a few transparencies. For the most predictable results, use freshly prepared bleaching solutions at a consistent temperature, preferably 24 C (75 F).

In the first minute of bleaching (at low temperature), a "just noticeable" amount of dye is removed. However, the rate of bleaching increases with longer immersion times.

When multiple bleaches are used, always bleach yellow or red before bleaching cyan and magenta. If the reverse order is used, the cyan and magenta dyes will be regenerated. (This does not apply to the magenta dye bleached by Kodak Red Dye Bleach SR-35.)

After bleaching, thoroughly wash the transparency in running water at 24 C (75 F) for at least 10 minutes or at 38 C (100 F) for at least 4 minutes. Thorough washing is important to prevent regeneration of

bleached cyan and magenta dyes during dry storage. (For water and energy conservation, 3 separate fresh water baths may be substituted for running water.) Following the final wash, rinse the transparency in Kodak stabilizer, Process E-6, for 1 minute and dry at a temperature of 43 C (110 F) or lower.

Because of their opalescent appearance when wet, transparencies on Kodak Ektachrome films for Process E-6 must be dried before the degree of bleaching can be accurately determined.

Kodak Retouching Dyes and Buffer

Kodak E-6 transparency retouching dyes, MX 952-6, consist of three 118-ml (4-fluid ounce) bottles of cyan dye concentrate, magenta dye concentrate, and yellow dye concentrate.

Kodak E-6 Retouching Dye Buffer, MX 952, concentrate is supplied in 118-ml (4-fluid ounce) bottles. Diluted in the proportion of 1 part buffer to 10 parts water, it is used to dilute Kodak E-6 transparency retouching dyes, MX 952-6, to working strength and to redissolve partially dried dyes in the palette.

Kodak E-6 transparency retouching dyes, MX 952-6, should always be stored in stoppered glass bottles to prevent evaporation. Evaporation adversely affects the penetration rate and duplication quality of the dyes.

Concentrated solutions of dyes and buffer are stable for at least one year if kept in stoppered glass bottles. The formation of a light yellow color in the concentrated buffer solution does not impair its action.

These dyes are recommended for use in correcting colors on all Kodak Ektachrome professional sheet films for Process E-6 (both original and duplicate transparencies) that are intended for photomechanical reproduction or duplicating onto film such as Kodak Ektachrome duplicating film No. 6121 (Process E-6). The dyes have been designed so that their spectral transmission characteristics are similar to those of the film-image dyes, when applied as recommended. Other dyes may not give satisfactory reproduction results, even though a visual match is achieved.

Applying the dye. For uniformity of dye application, premoisten the base side of the area to be retouched, using a tuft of cotton dampened with a solution of 1 drop of Kodak Photo-Flo 200 Solution in 30 ml (1 fluid ounce) of cool water. Use the damp cotton tuft to remove excess dye during the retouching operation.

Dyes may be added to either side of the transparency. However, dye application is usually faster on the base side because it penetrates the

134

gel backing easier and dries faster. In cases where sharp retouching is required or where dye saturation on the base side is insufficient to produce a high enough density, dyes must be added to the emulsion side. In addition, applying dyes directly to the emulsion side eliminates the effect of parallax that is possible when dyes are applied to the base side due to the thickness of the acetate base separating the dye from the emulsion. Even though the acetate is only approximately 7 mm thick, any dye applied to the base side will be on a different plane and, therefore, will not align exactly with the images on the emulsion side. This may result in shadows, which are intensified and show up as parallax when projected. When applying dye to the emulsion side, do not premoisten the area.

The three dyes—cyan, magenta, and yellow—may be mixed in the palette in any proportion to produce the proper retouching color. Do not mix large quantities for storage because some combinations are unstable. The dyes may be applied to the transparency as mixtures or individually.

Increasing or decreasing dye strength. The dyes can be used at full strength as supplied, or if weaker solutions are required, they can be diluted with buffer solution. If large quantities of dilute dye are required for tray dyeing, equal volumes of dye concentrate and dilute buffer can be combined and then further diluted with water.

The penetration rate of E-6 transparency retouching dyes, MX 952-6, is increased when the dyes are mixed with dilute acetic acid. Use 1 drop of 7 percent acetic acid mixed with 10 drops of undiluted dye. This solution is useful when maximum dye penetration is needed and a semi-dry brush technique, for fine detail, is being used. Greater acidification should be avoided because of the adverse effect of acid on dye uniformity and reproduction color quality.

To make 1 litre of 7-percent acetic acid solution, add 70 ml of glacial acetic acid to 930 ml of water, or add 250 ml of 28 percent acetic acid to 750 ml of water.

Caution: Add the acid to the water, never water to acid.

Partially dried dyes in the palette can be redissolved with dilute buffer solution. Completely dried dyes should be discarded. If a slight loss in penetration and color quality in reproduction can be tolerated, the dried dyes can be redissolved in dilute buffer solution. Do not use water.

Assessing density. Dye densities may be assessed by viewing the retouched transparency through Kodak Wratten filters No. 25 (red), No.

58 (green), and No. 47B (blue) by transmitted light. There is a significant hue shift from wet to dry dye. Dry the retouched area before making color correction judgments. Forced air may be used for rapid drying at a temperature of no more than 43 C (110 F).

Removing Dye Retouching

Retouching dye that has been applied to the emulsion side of a transparency can be removed by washing the transparency thoroughly in running water at 24–38 C (75–100 F). Follow the wash with a 1-minute rinse in Kodak stabilizer (Process E-6) for long-term stability. If long-term stability is not a concern, rinse the transparency in a bath containing a few drops of Kodak Photo-Flo 200 Solution. Dry the transparency at a temperature not exceeding 43 C (110 F). To totally remove all dye from the base side of a transparency use Kodak Total Dye Bleach SR-30.*

*While Kodak products were used to provide these recommendations, equivalent products can be used if desired.

10

Flat Copying

Almost any organization that has a research or a sales department makes use of audio-visual techniques. Very often, presentations are prepared from simple typed copy or artwork, and using 35 mm slides for this purpose has proven to be extremely successful. Anywhere ideas or concepts have to be communicated, the use of projected material has great value. When presentations deal repeatedly with a specific area, the company will usually develop a stock file. Pictures of the products, processes, and sales concepts can be drawn from the file and utilized as required. Standardizing this material to 35 mm and using slide files and projection trays to store them, simplifies handling. If a series of pictures depicts construction of a plant or sites being considered for land acquisition, duplicate sets of key slides aid in preparing a presentation.

ADDING TITLES OR CAPTIONS

A slide show of this type can be materially improved by the addition of titles, captions, or other explanatory material to individual slides. By utilizing high-contrast film, a two-part developer, and Color Key or Diazo materials, you can add titles to any slide. Many titles produced in this manner are shown in a single evening's viewing of television. Commercials, as well as instructional slide shows, make frequent use of this technique. Once the titles are planned, the next step is the actual lettering or typesetting. There are many materials in the graphic arts field that end themselves readily to producing professional-looking titles.

FILM FOR COPYING BLACK AND WHITE

When originals are black and white, typed or artwork, making a good copy is relatively simple if you use high-contrast copy film No. 5069

Kodak Developer	Properties and Uses
D-8	Very high contrast. Line and continuous-tone copying.
D-11	High contrast. Continuous-tone copying.
D-19	Moderately high contrast.
D-76	Low activity, moderately fine grain.
DK-50	Medium activity, general purpose.
Kodalith A-B	Extremely high contrast. Line work on Kodalith films.
Kodalith Fine-Line	Extremely high contrast. To preserve fine lines on Kodalith films.

manufactured specifically for this purpose by Kodak. It is a panchromatic film made for line copying and has a tungsten ASA of 64. Using this film to photograph white paper with black type will produce,when processed, a reversal of the original. The white background will be black, and the black type will be clear and transmit light from the projector. This offers superior readability and prevents glare from the screen from causing discomfort to the viewers in a long presentation.

TITLING MATERIALS

Stick-On Letters

Most stationers stock various sizes of dye-cut vinyl letters on a peel-off backing. These letters may be singly removed and placed on a white board or paper, thus preparing them for photography. Those of you who have a movie title set of letters may use them for three-dimensional titles. These can be photographed on high-contrast film and will produce clear letters on a solid black background. All copy should be photographed in scale to fit the individual slide it is going to be combined with. After processing, if you reverse it (by contact printing), you have a clear film with black letters that can be directly sandwiched with the slide.

138

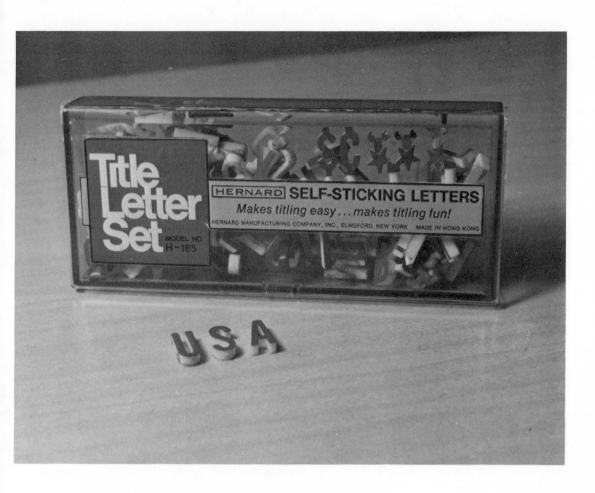

The Hernard Manufacturing Company makes three-dimensional,
self-stick letters, which can give your presentation an individual look.

Rub-Off Letters

There are a number of rub-off letters that most art stores carry.
The most common are Chartpak and Letraset. Both companies have
catalogs with hundreds of typefaces—from simple to elaborate—and
make large assortments of symbols and border designs. These materials
are used by placing the appropriate letter on a properly lined sheet of
white paper and burnishing over it with any round, smooth, hard surface.
In this process, the letter transfers from its wax support directly to the

The Edmund Scientific Company retails a Slide Title Kit that permits you to make typed titles without a camera or darkroom work. The stencil paper supplied with the kit is inserted in a typewriter. After the title is typed, the paper is then mounted in the cardboard mounts, also supplied with the kit.

white paper. These letters are intense black and are excellent for high-contrast photography.

Free-Hand Lettering

For those of you with artistic ability, free-hand lettering can be done, and all sorts of elaborate designs and drawings added to the slides. From the high-contrast film, by making either Diazo or Color Key titles,

you can add color or have clear letters with colored backgrounds. Letters with bold design are more effective than typewritten words on a slide. These slides can be used directly as prepared in a sandwich, or they can be rephotographed and reduced to a single film plane, which makes projection easier.

Edmund Scientific Company Kit

A quick way of adding typed titles to a slide show is with a kit made by the Edmund Scientific Company. You type a short caption on special transparent material in any typewriter. The material is then mounted in cardboard mounts supplied with the kit. The titles can then be sandwiched to the appropriate slide or reproduced on a single film plane.

Free-hand lettering may be preferred over stick-on or rub-on letters and can be photographed in the same manner. White paper and India ink or intense black magic marker will insure maximum contrast.

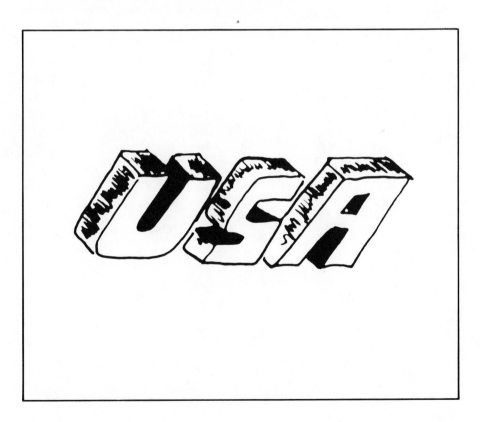

Sometimes,
it is more convenient
to use self-stick, vinyl
letters rather than rub-on
letters for short titles.

After placing the letter in
position, burnish over it with a
firm, rounded surface to
transfer it to paper or
cardboard.

142

The faint line on the paper shows how the letters are aligned to achieve straight titles.

The title in the contact frame is ready to be photographed.

143

To produce a photoon (photo cartoon), type and draw the caption you want on a sheet of paper to the proper proportions. Make a high-contrast negative of the caption and reverse it by contact printing. Then register the caption with the film positive of a photograph and duplicate it on 35 mm film.

FILTERS FOR COPYING COLORED LETTERING ON WHITE PAPER WITH PANCHROMATIC FILM

Paper color	Ink color	Filter color
White or yellow	Blue	Red
White	Red	Blue
White or yellow	Blue or red	Green
White or yellow	Purple	Green
Green	Black, blue, or red	Green
Blue	Black or red	Blue
Pink	Black or blue	Red

Color of Original	To Photograph as Dark on		To Photograph as Light on	
	Black-and-White Ortho Material	Black-and-White Panchromatic Material	Black-and-White Ortho Material	Black-and-White Panchromatic Material
	Use these filters:		Use these filters:	
Magenta	Yellow Green	Green	Blue Magenta	Red Magenta Blue
Red	None	Green Blue	Not recommended	Red
Yellow	Blue Magenta	Blue	Yellow Green	Yellow Green Red
Green	Blue Magenta	Red Blue Magenta	Yellow Green	Green
Cyan	Not recommended	Red	None	Green Blue
Blue-violet	Yellow Orange Green	Green Red	Blue Magenta	Blue

*These are not the only filters which can be used to produce the desired effects. Practical experience will show which variations of the suggested filters can be used with certain hues of the original color.

ADDING COLOR

Color can be added to the slides by using tinted tapes, which are applied directly to the film. These adhesive tapes can be purchased in rolls. They are made in a number of widths and can be applied to headings and individual lines of type in varying colors. This permits the addition of two, three, or more colors, if you desire, to your black-and-white slides. Since the tapes can be cut with an X-acto knife or single-edge razor blade, they can be made to conform to various areas of graphs or charts to delineate differences between years, times, sales, etc. For those who prefer a white background and black type, the original slides can, by contact printing, be reversed so they duplicate the original copy. This method produces a slide superior to those made directly with reversal-color material. Both methods may be tried to determine which one will be more satisfactory. If you choose to use color transparency film, the color tapes may be applied directly to the original black-and-white art material, or filters may be used on the camera lens to produce tints and colors

in the background. These are available from graphic arts or art stores. Using color in these presentations adds impact, and some of these manufacturers have instruction books available for the use of their materials.

COMBINING SLIDES WITH SOUNDTRACKS

Frequently slides of this type are combined with a soundtrack tape for presentation. Kodak makes a simple, inexpensive, electronic pulser that automatically changes the slide to correspond with the soundtrack. It is the Kodak Carousel Sound Synchronizer Model 2, designed to work with any Kodak Carousel projector. You can use the unit and a two-track (stereo) tape recorder to prepare your own multimedia programs. Programs of this type help to simplify the presentation and insure that it is delivered in the most organized manner. They also guarantee uniformity in the delivery of repeated presentations. For those interested in more elaborate multimedia programs, there are many sound and electronic specialists who rent or sell equipment—including computers—that will produce programs using as many as 12 to 15 projectors controlled by audio-tape or punched-taped programs. These are usually reserved for professional presentations and require considerable investment and technical training.

Slide-Mounting Equipment

For many years there has been controversy as to the most practical methods of mounting. Professionals have varying viewpoints on this matter. There is one school that maintains that the cardboard or plastic mounts without glass are more practical and in many ways superior to glass mounts. Others feel that the protected surface of glass is a plus. A third school believes that only special glass that prevents Newton rings from forming is best. These are factors that you will have to consider for yourself to determine which method of mounting works best for you.

HEAT-SEAL MOUNTS

The simplest and least expensive method of mounting 35 mm slides is in cardboard heat-seal mounts. Heat-seal mounts can be individually mounted by using an electric iron if one is extremely careful. If you plan to do a fair amount of mounting, it pays to invest in one of the small electrically-heated manual units such as the Seary slide-mounting press. Seary also offers an inexpensive film cutter that makes precision cutting of the slides easy. These cardboard mounts are basically the same mounts that Kodak and other film manufacturers supply when they do film processing for you.

OTHER METHODS

Non-Glass Mounts

In addition to the heat-seal method, there are a number of other expensive and inexpensive techniques for mounting your slides. The least expensive of the non-glass mounts are the simple cardboard heat mounts. There are also cardboard mounts with self-adhesive peel-off covers that do not require the use of a heat press. Other companies offer cardboard slip-in mounts, which are laminated sandwiches having one side open so

Seary's inexpensive heat-seal press permits the use of cardboard mounts. Each slide must be locked in place and is released by rotating the black knob on its face.

the film may be inserted. Plastic mounts, such as the Pakon, are available in bubble packs of 50 or 140 mounts for the infrequent user. Each of these systems offers some advantage in cost, convenience, and durability.

Glass Mounts

Mounts that use glass will be more expensive per slide. In addition, slides mounted in glass tend to show up less sharp when projected. This is because the glass absorbs some of the light as it passes through and decreases the quality of your slide. In this category, there are mounts of stamped aluminum that utilize two pieces of glass and a frame mask that holds the slide. Spiratone sells an extremely thin, snap-together 2″ × 2″ plastic mount that fits most Carousel trays, including a 140.

Cut the frames carefully or you may ruin valuable pictures.

Seary manufactures a heavy-duty, automatic, heat-seal slide-mounting press. The operator inserts the folded mounts in the top opening. Sensors close the press for a predetermined time and stack the mounted slides in sequence.

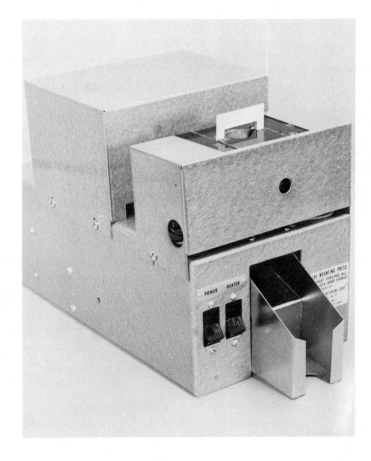

The Seary film cutter has an illuminating bulb that simplifies spacing and cutting.

Choosing the Mount that Will Protect Your Slide

In choosing slide mounts, maximum protection of the slides should also be considered. Cardboard mounts can, over a period of time, deteriorate. the surface of a glass mount can develop a fungus that attacks the slide and destroys the image. The thickness of the mount must also be considered because not all slide trays will handle all mounts.

NON-STANDARD MOUNTS

Every situation does not call for the use of standard-size slide mounts. For anyone requiring other than standard mounts, the Erie Color Slide Club offers a slide selector mask with eight assorted openings. They are available as self-adhesives or heat-seal mounts and can be or-

Erie's slide-selector mask, consisting of eight shapes, helps you select the best odd-shaped mount for your slide.

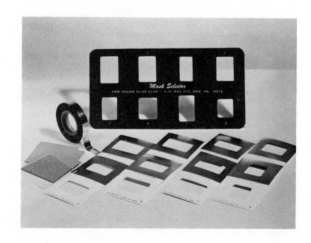

150

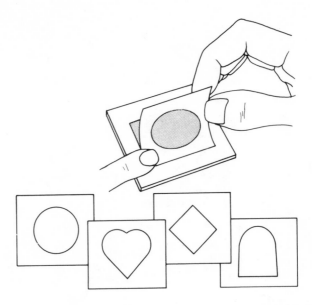

Using odd-shaped slide mounts can dress up your slides or cover unattractive areas.

dered directly from the club. Erie sells cover glasses that are 1/300-inch or 1/400-inch thick in packages of 50. A polyester film tape ⅜-inch wide can be used to bind slides between glass once they are placed in a cut-out mask. This same tape, because it is so thin and totally opaque, is marvelous for getting straight edges when masking slides down to an unusual size for which there is no mask. The tapes are available in silver, gold, and red. It would be worthwhile, if you are going to mount your slides, to familiarize yourself with the materials that Erie has available.

Smith Victor's slide-sorting tray and light box facilitate editing and arranging a slide show.

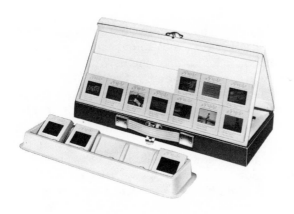

151

To protect your slides from dust and fingerprints as well as to keep them in order, file them in preformed acetate pages and catalog them in a looseleaf binder. *(Photo by 20th Century Plastics.)*

Mounts of Unusual Shapes

Two sources for interesting slide mounts of unusual shapes are the Edmund Scientific Co. and Spiratone. They have a variety of heart, key hole, star, diamond, circle, and oval shapes that can be used to dress up a slide show, or cover an unattractive area on a slide, thus improving it.

SLIDE SORTERS AND FILES

A slide sorter, which is a wedge-shaped container with an internal light bulb and a formed plastic surface, is convenient for viewing a sequence of slides for arrangement prior to placement in trays. Several models of sorters and slide files are manufactured by Smith Victor Corporation, while 20th Century Plastics sells albums with vinyl pages formed to hold 20 slides per page. The advantage of this method of filing is the ease with which any specific slide can be located. By holding the individual page to a light source you can view 20 slides in an instant. These crystal-clear pages can be used for previewing slides as well as protecting them from excessive handling. Spiratone sells a viewer with its own light source designed to hold these slide-file pages while they are in the albums.

152

Building Your Own Slide Duplicator

A slide-duplicating system consists of any single-lens reflex camera, a stand to hold the camera steady, a bottom-lit light box that will accommodate filters, and a slide holder.

The Camera Stand

Since the most important element in this system is the camera stand, purchase a piece of equipment especially made for this purpose. However, an old enlarger that is no longer functional can be cut down. In any event, as long as you have a rigid support that will hold the camera firmly for extended exposure periods and support it parallel to the baseboard, either method will work well.

The quick release for the camera is not essential, but it offers considerable advantage because it permits removal of the camera at the press of a lever. There are several types of releases on the market. If the quick release is not used, design a standard ¼″ 20 screw to attach the camera rigidly to the stand.

The Light Box

Your light box can be constructed cheaply out of a variety of containers. What is important to take under consideration when making the light box is the buildup of heat. Paper or cardboard, therefore, are not ideal materials. Electronic dealers sell inexpensive, stamped sheet metal or aluminum boxes. Some even come with hinged covers. You can also use a tool box, a tackle box, or a small metal kitchen cannister. As long as it is large enough to accommodate the socket and light bulb, and a switch can be mounted, it is suitable as a light box.

In the side of the light box facing away from the work area, it is advisable to drill three or four ¼-inch or larger holes near the base of the box so cool air may enter. A matching three or four holes near the top of the back of the box should be drilled for the rising hot or warm air to leave. This will set up a convection motion and keep the box reasonably

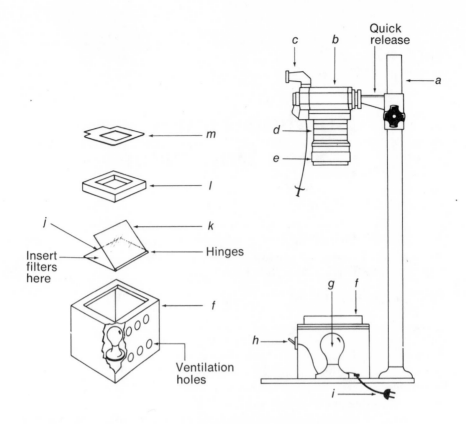

A slide-duplicating system should consist of *(a)* a copystand, and *(b)* any 35 mm camera with lens interchangeability, *(c)* a right-angle finder, *(d)* extension tubes, and *(e)* a normal or macro lens. The light box *(f)* includes *(g)* a 50–100-watt light bulb, *(h)* an on/off switch, *(i)* a cord and plug for 11-volt AC, *(j)* a sheet of flashed opal glass hinged to *(k)* a sheet of clear glass, *(l)* a spacer, and *(m)* a slide holder.

cool. Heat will not damage your films even when the light is left on for considerable periods of time.

Once you have determined what size opening will accommodate your largest transparencies, cut a hole in the top of the box. Over the opening, place a piece of clear glass and tape it down on all four sides with masking tape. A sheet of flashed opal glass should be placed on top of this. Do not tape the opal glass on all four sides, as you did the glass, but at the top only to form a hinge. Filters may then be inserted beneath the opal glass.

For illumination you can use a standard household 50-, 75-, or 100-watt bulb. You can use the Sylvania Soft White Bulb, or any similar

bulb with a light milky surface. They provide very diffused, even illumination.

A simple on-off switch, either of the push or turn variety, is handy placed on the front of the box where it can be reached easily. If you are interrupted, it is simple to flick the switch off so the box will not build up heat while you are not working. A standard UL-approved, 117-volt AC cord is wired into the box. The accompanying drawing indicates a simple procedure for wiring the switch to the circuit. This requires no special skill. In each spot where wire is exposed, carefully tape it with electrical tape to prevent shorting against the box. Where the wire passes into the box, mount a rubber grommet insulator to prevent abrading and shorting through continued use.

The Slide-Holder Platform

Affix a platform approximately one to two inches above the light box. This will be your slide holder. The only point to remember about its construction is that you want the slide to slip into a rather snug-fitting U-shaped channel. Then when doing a series of slides with similar magnifications, you can replace the slides in sequence without reframing. The slide holder can be made of ordinary mat board—cemented or taped together. This platform above the glass gives you the advantage of not having your light source in sharp focus. Since the emulsion of even several slides is only thousandths of an inch thick, very little shutting down of the lens is required to get your image perfectly sharp. This prevents any dust, dirt, or scratch marks that might be on the glass or filters from coming into sharp focus.

An Enlarger Color Head

As an extra convenience you can add an enlarger color head to your system. After removing the high-intensity illumination and inverting it, mount it to your work table. Then install a 100-watt light bulb. This permits adjusting filtration without handling individual filters.

Appendix

LIST OF MANUFACTURERS

Besseler Photo Mktg. Co., Inc.
8 Fernwood Road
Florham Park, NJ 07932

Bogen Photo Corp.
100 S. Van Brunt St.
Englewood, NJ 07631

Canon U.S.A. Inc.
10 Nevada Drive
Lake Success, NY 11040

Eastman Kodak Co.
343 State Street
Rochester, NY 14650

Edmund Scientific Co.
555 Edscorp Building
Barrington, NJ 08007

Erie Color Slide Club, Inc.
Box 672 Main P.O.
Erie, PA 16512

Focus International
A Division of Sickles, Inc.
Box 27965
Tempe, AR 85282

M. Grumbacher, Inc.
460 W. 34 St.
New York, NY 10001

Hernard Mfg. Co., Inc.
Elmsford, NY 10523

Nikon, Inc.
Subsidiary of Ehrenreich
Garden City, NY 11530

Nuclear Products Co.
P.O. Box 1178
El Monte, CA 91734

Pako Corp.
6300 Olson Memorial Hgwy.
Minneapolis, MN 55440

Photo-Therm
110 Sewell Ave.
Trenton, NJ 08610

Retouch Methods
P.O. Box 345
Chatham, NJ 07928

Rollei of America
5501 S. Broadway, Box 1010
Littleton, CO 80121

Rosco Laboratories Inc.
38 Busch Ave.
Port Chester, NY 10573

Seary Mfg. Corp.
19 Nebraska Ave.
Endicott, NY 13760

Sickles, Inc.
P.O. Box 3396
Scottsdale, AR 85257

Smith-Victor
Griffith, IN 46319

Spiratone, Inc.
135-06 Northern Blvd.
Flushing, NY 11354

Starer Chemical Co.
P.O. Box 15536
Durham, NC 27704

Static Control Systems
Visual Control Division
3M Company
3M Center
St. Paul, MN 55101

3M Company
P.O. Box 33600
St. Paul, MN 55133

Tiffen Optical Co.
71 Jane Street
Roslyn Heights, NY 11577

Testrite Instrument Co. Inc.
135 Monroe St.
Newark, NJ 17105

20th Century Plastics, Inc.
3628 Crenshaw Blvd.
Los Angeles, CA 90016

Index